FLOWERS

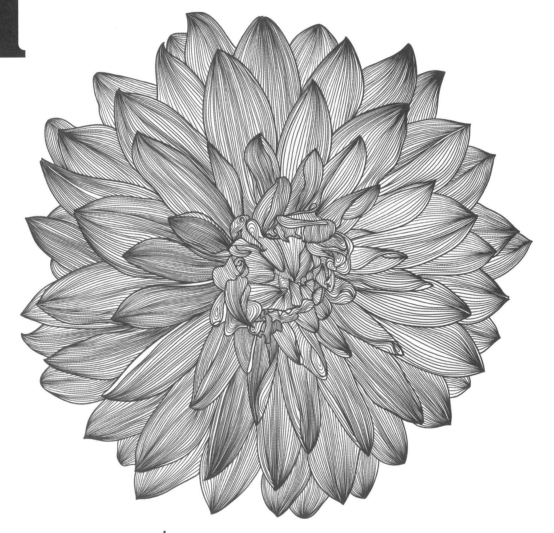

EXTREME COLORING BOOK

Published by **S** SCRIBO
The Salariya Book Company Ltd
25 Marlborough Place, Brighton BN1 1UB
www.salariya.com
www.book-house.co.uk

ISBN-13: 978-1-910706-29-9 (PB)

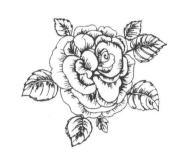

SALARIYA

3 5 7 9 8 6 4 2

A CIP catalogue record for this book is available
from the British Library.
Printed and bound in China.
Reprinted in MMXVI.

Illustrations by Henu Studio and Shutterstock.

Visit our website at **www.book-house.co.uk**
or go to **www.salariya.com** for **free** electronic versions of:
You Wouldn't Want to be an Egyptian Mummy!
You Wouldn't Want to be a Roman Gladiator!
You Wouldn't Want to be a Polar Explorer!
You Wouldn't Want to sail on a 19th-Century Whaling Ship!

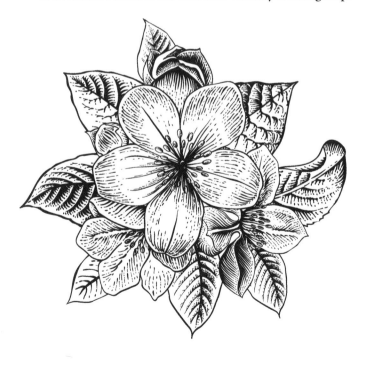

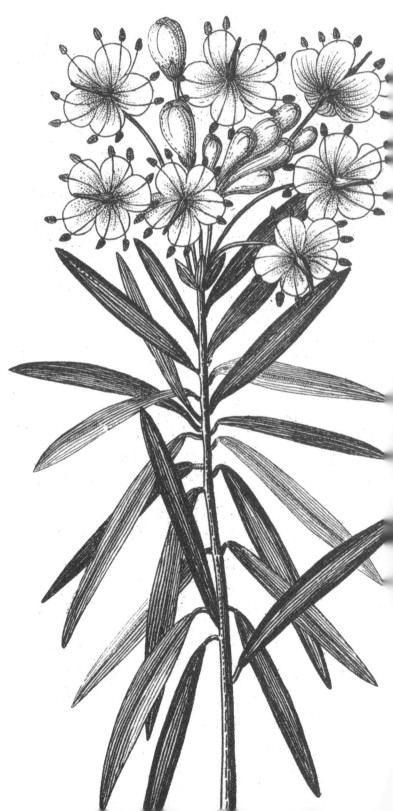

FLOWERS

EXTREME COLORING BOOK

SCRIBO

INTRODUCTION

Gardens are a paradise of beautiful flowers, plants, birds, insects, and fluttering butterflies that have inspired countless writers, poets and artists over the centuries. Be inspired by these detailed line drawings waiting for you to bring them to life with color.

You may find that colored pencils are more versatile to use than felt tip pens. These pencils are available in a huge range of colors, they have a soft delicate quality and different colors can be blended on the pages. If you find some areas of pattern too intricate to color, you can flood these areas with light tones to allow the underlying patterns to show through.

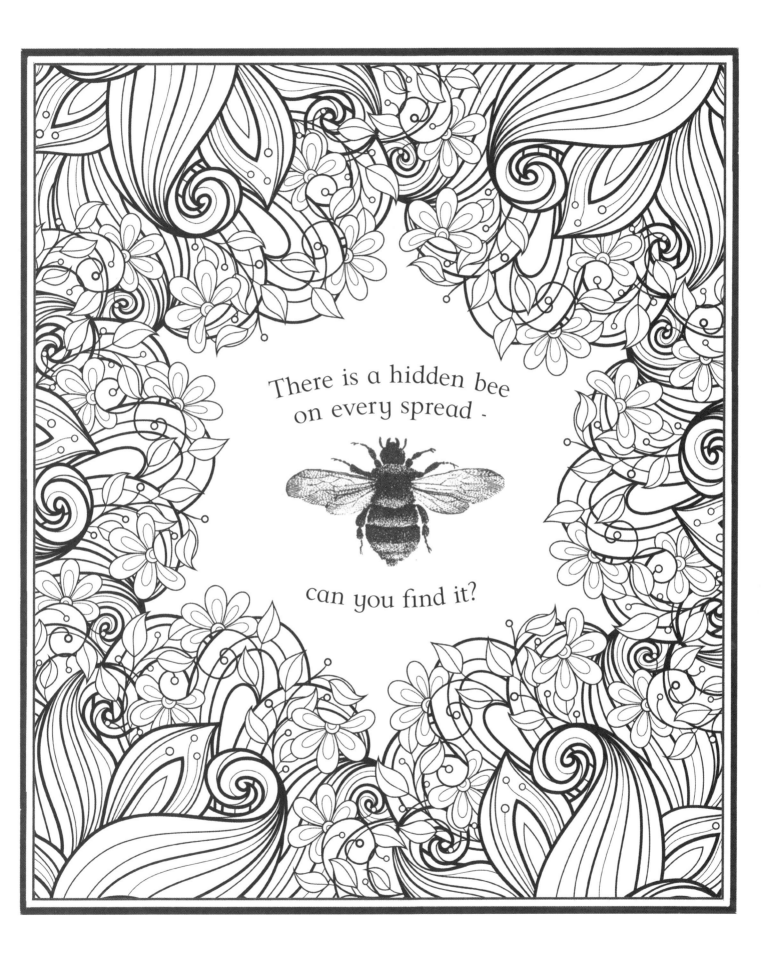

There is a hidden bee
on every spread -

can you find it?

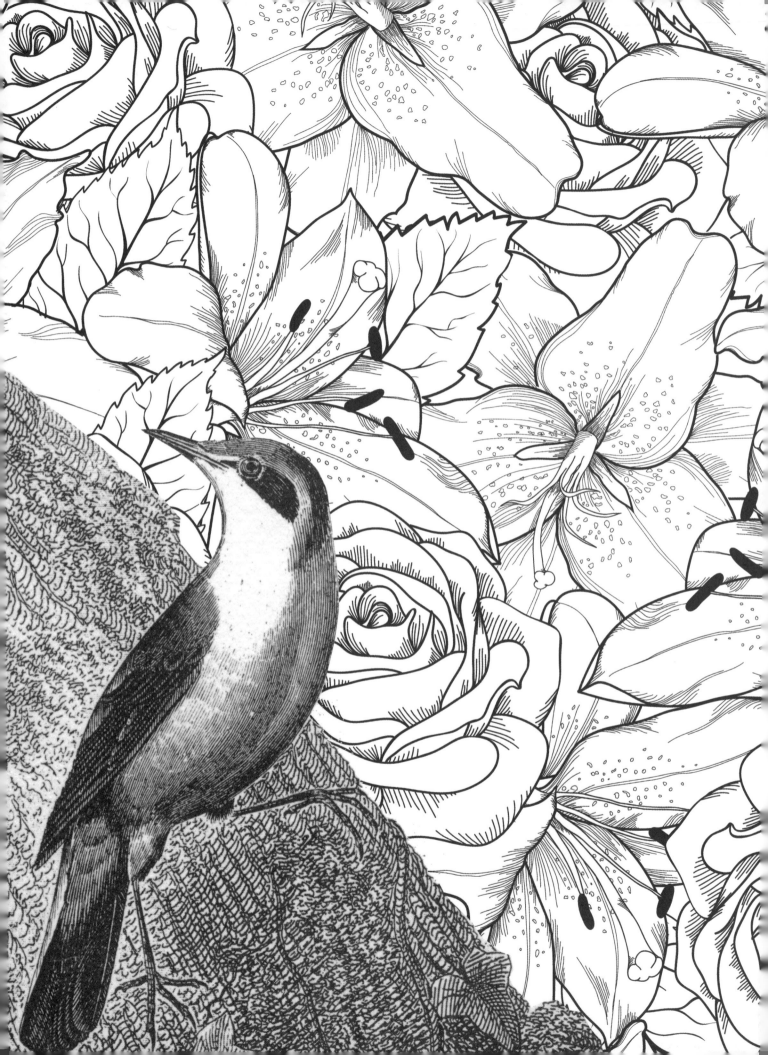

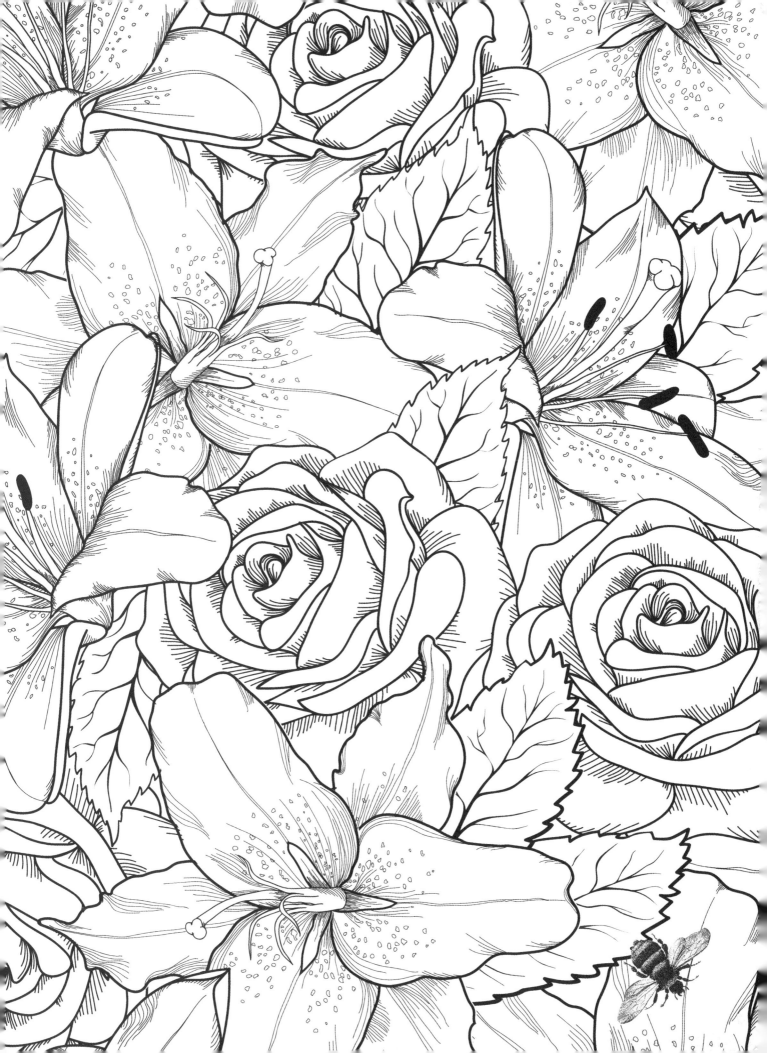

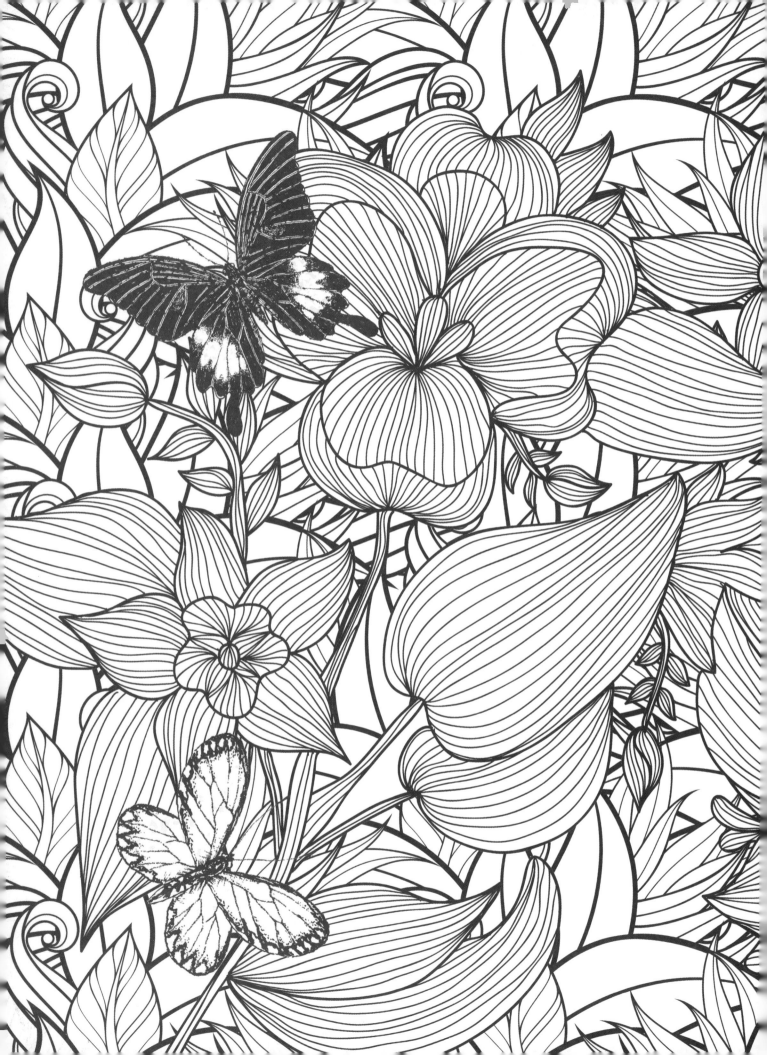

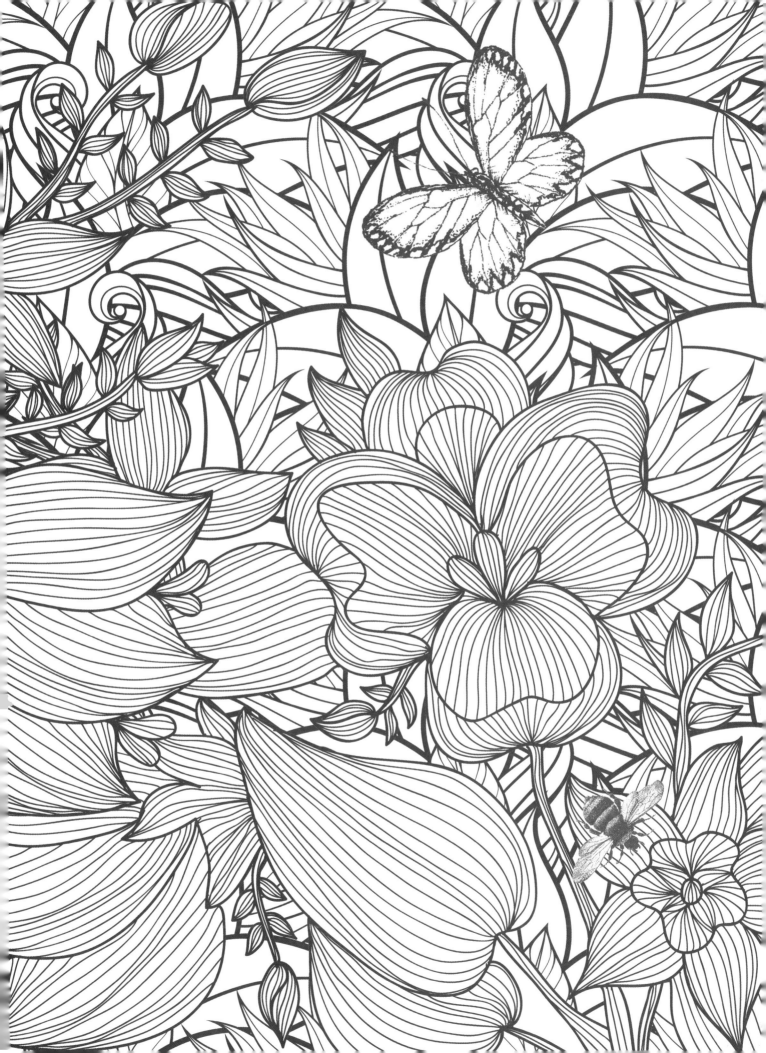

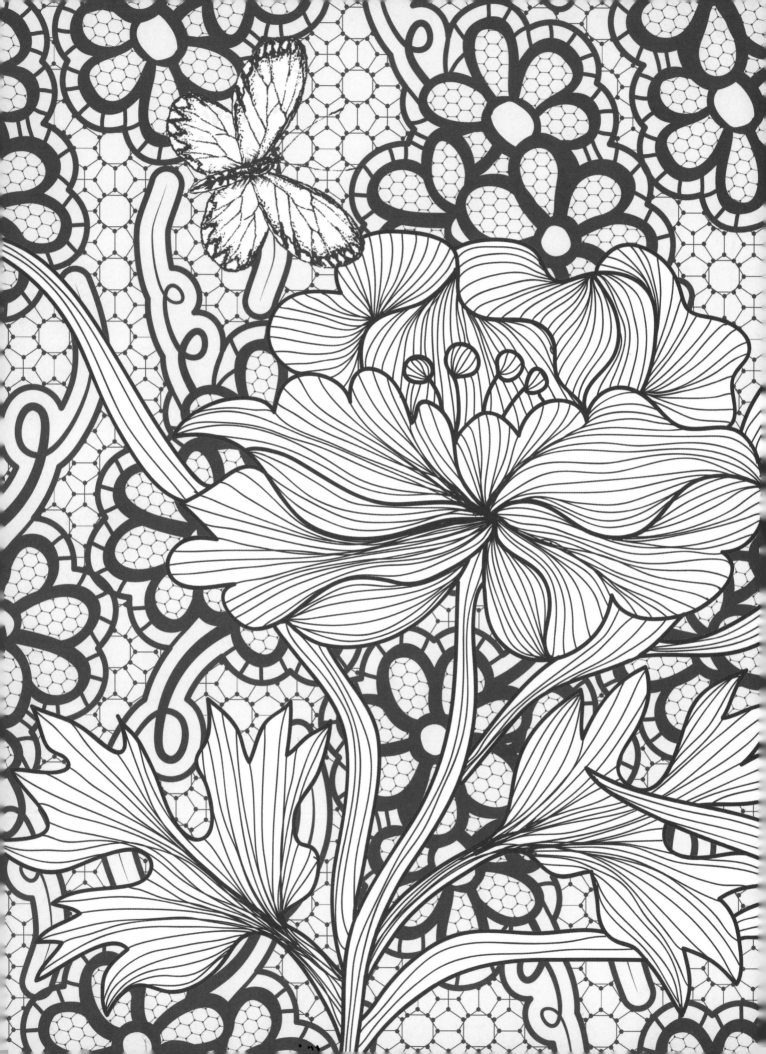

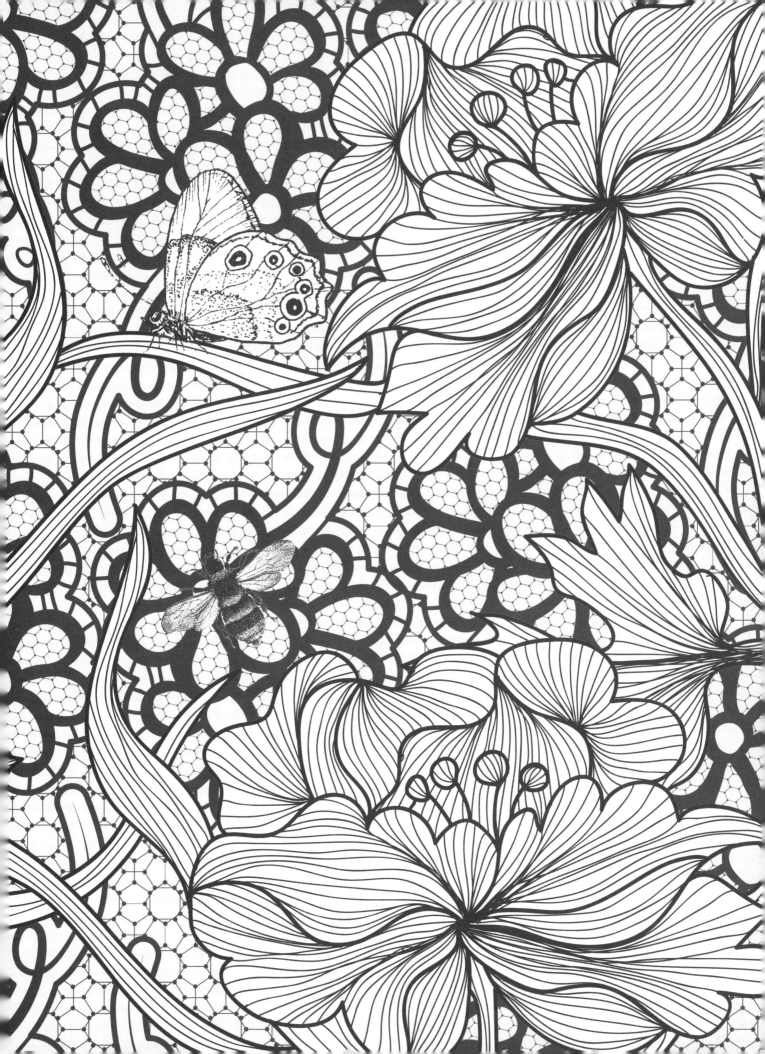

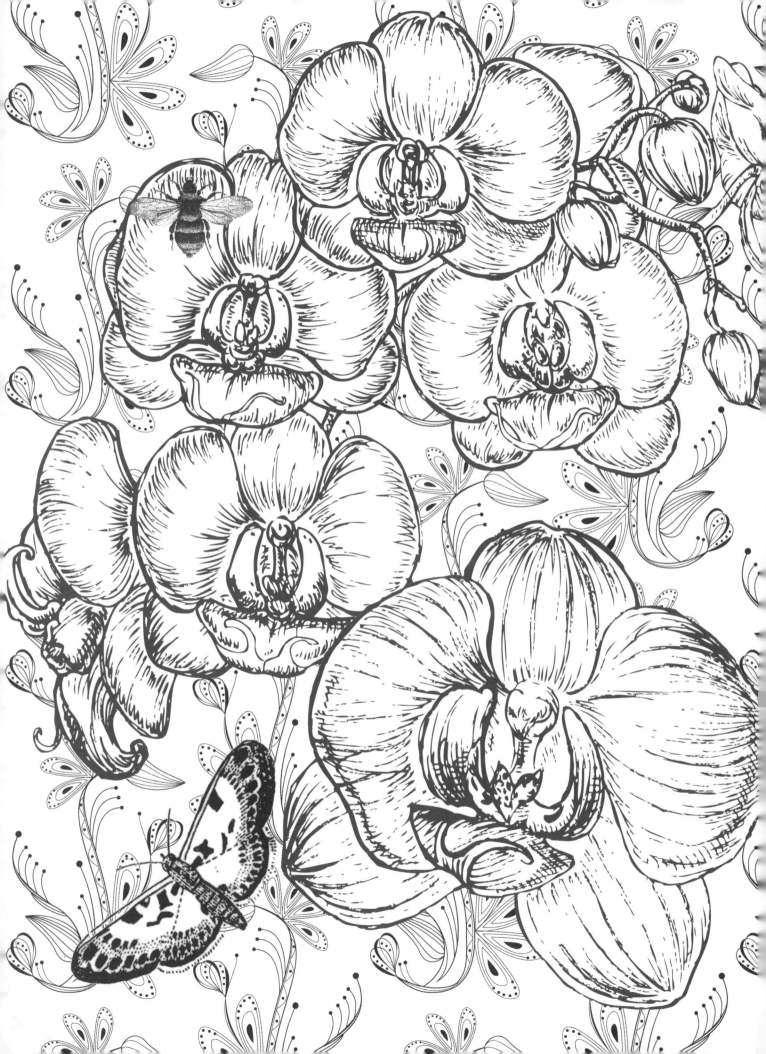

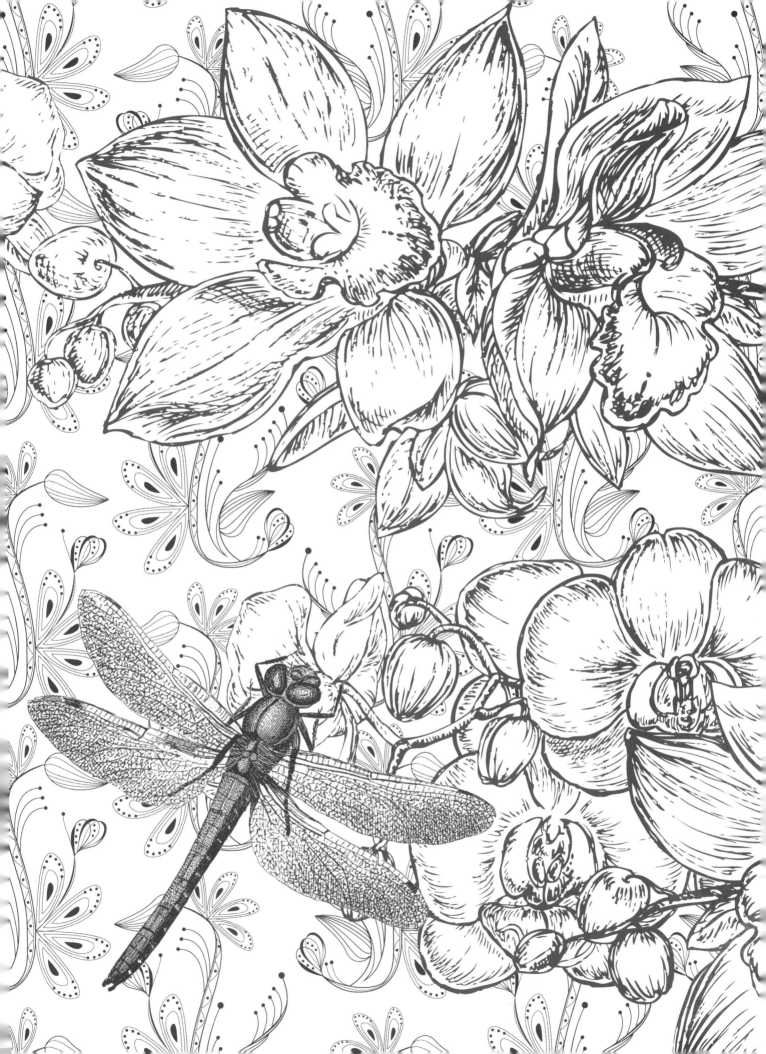

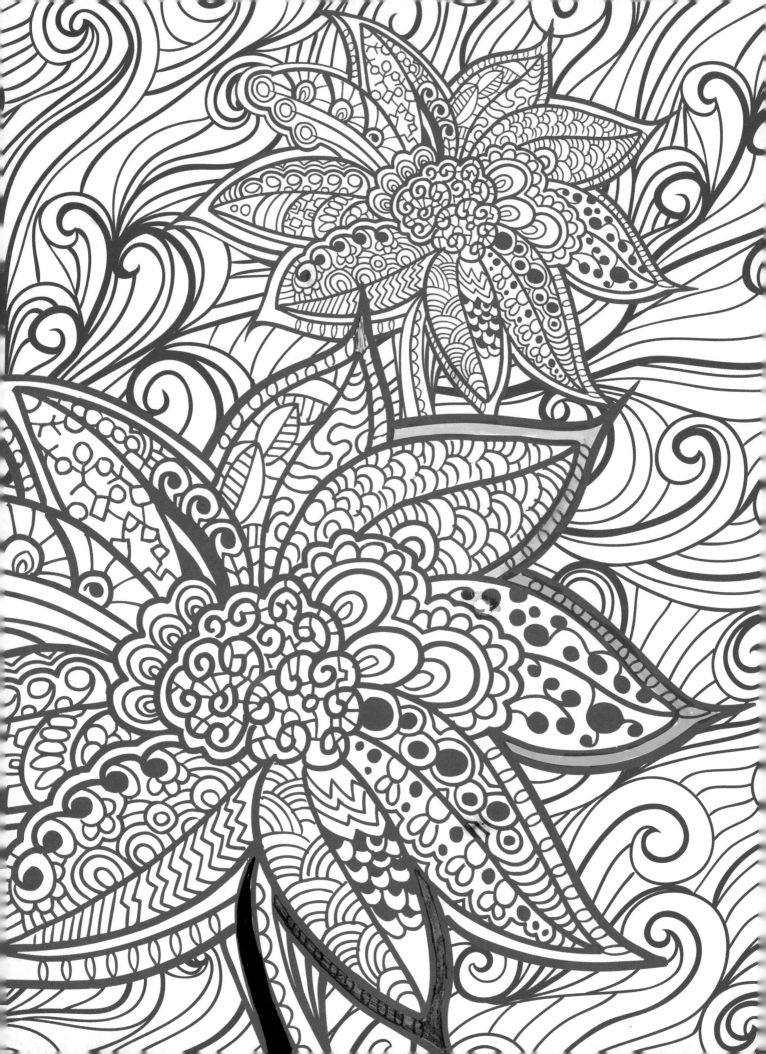

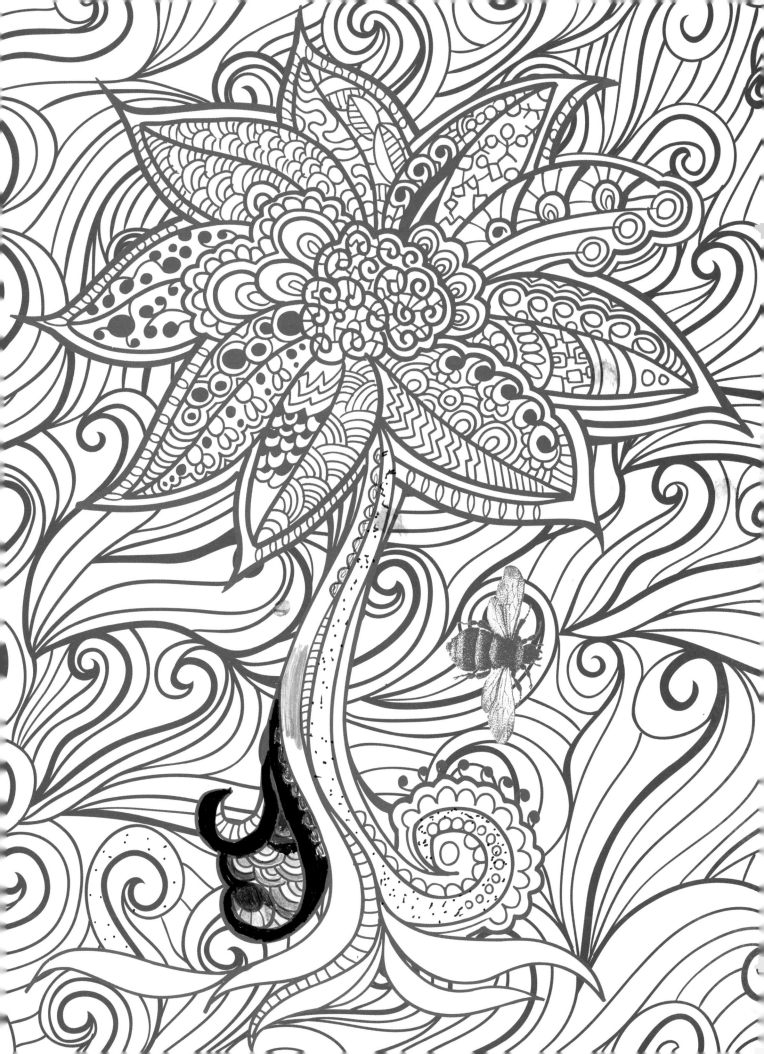

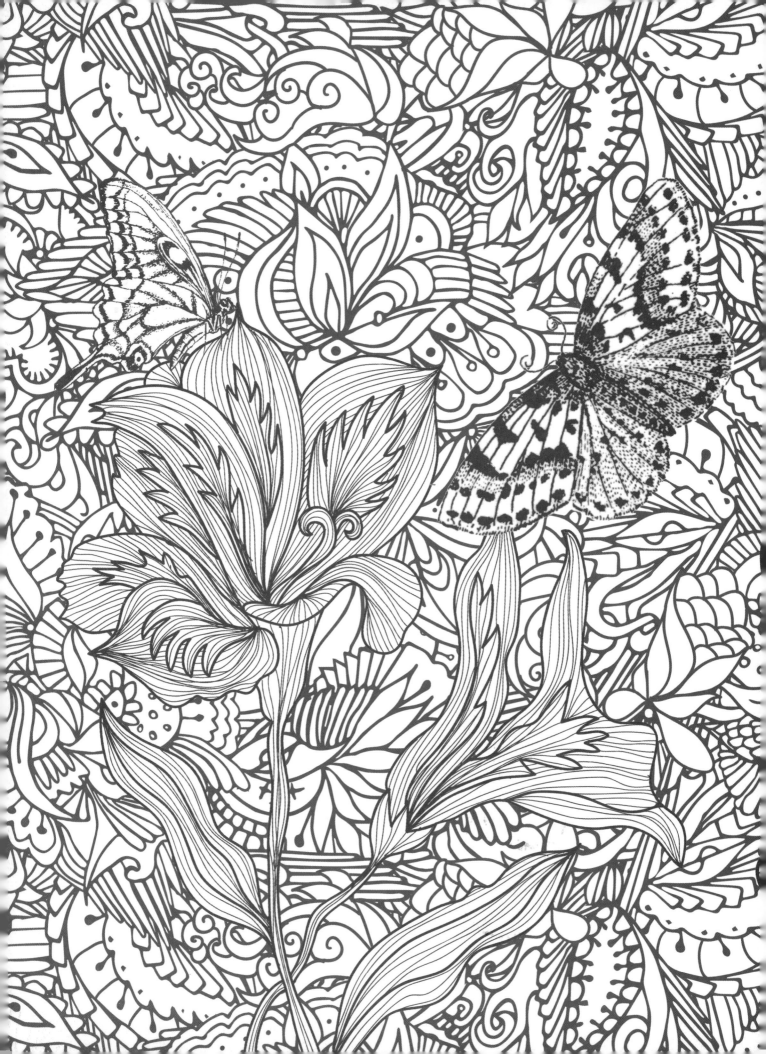

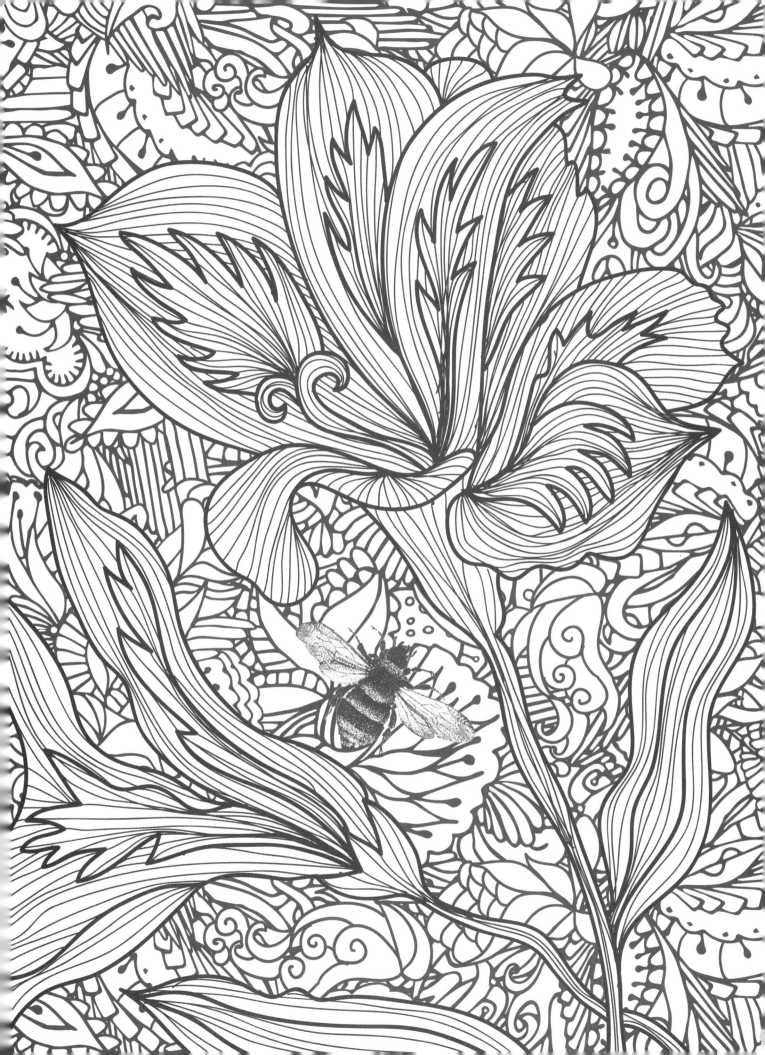

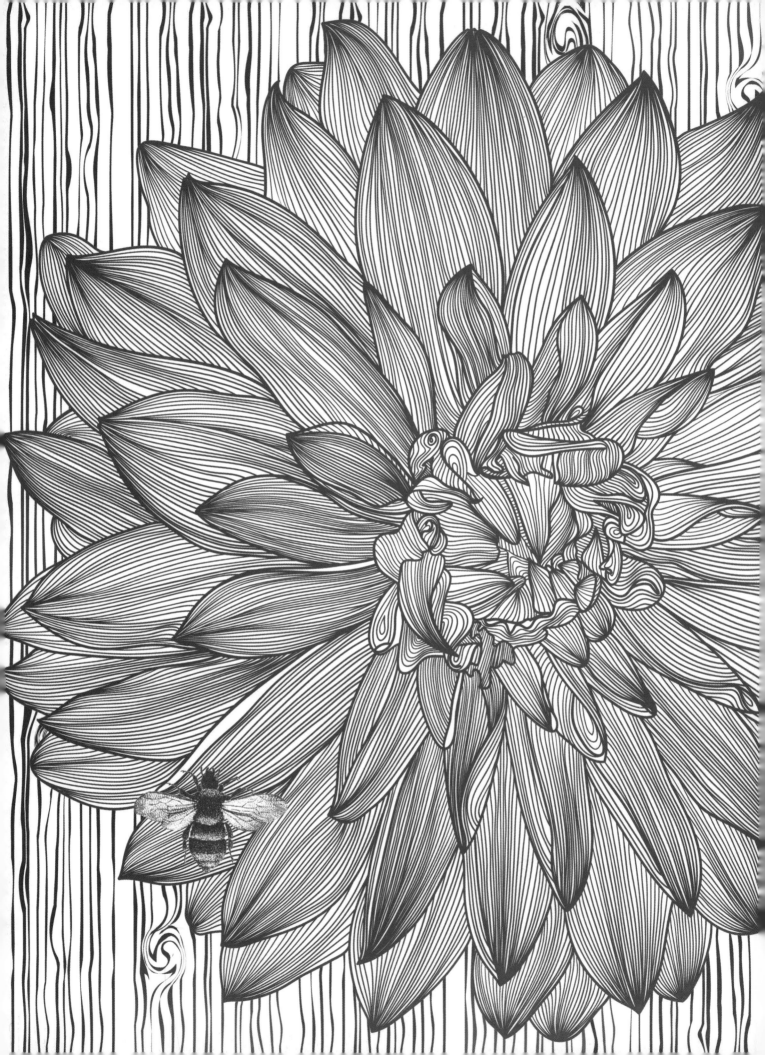

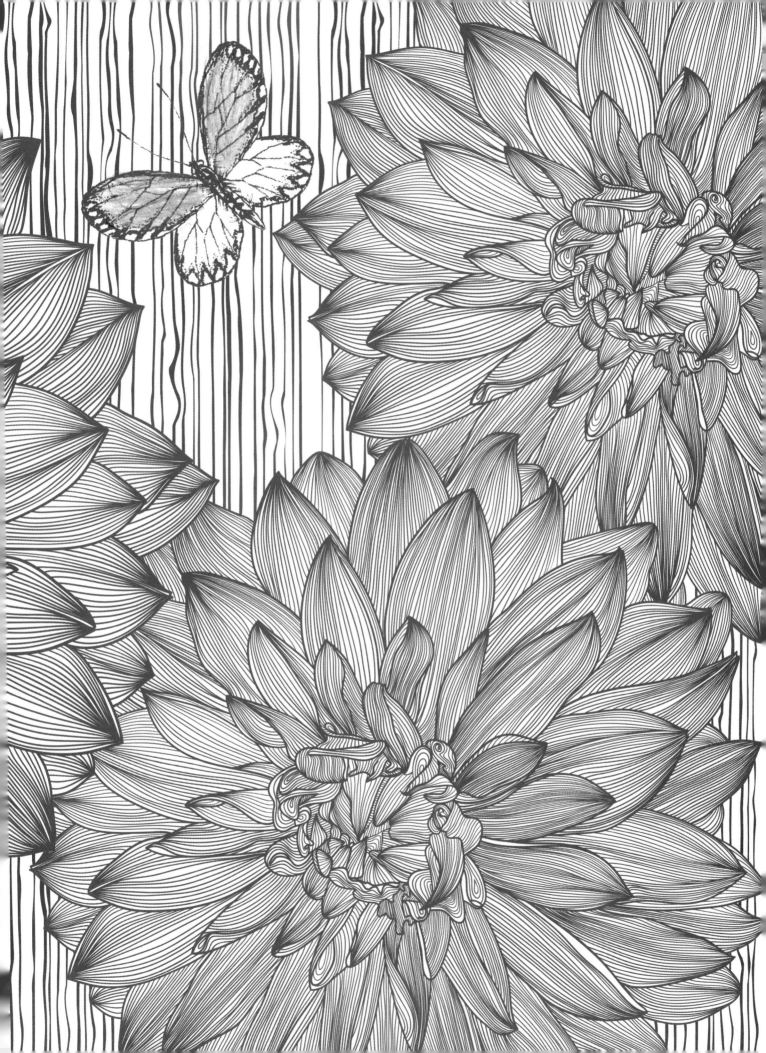

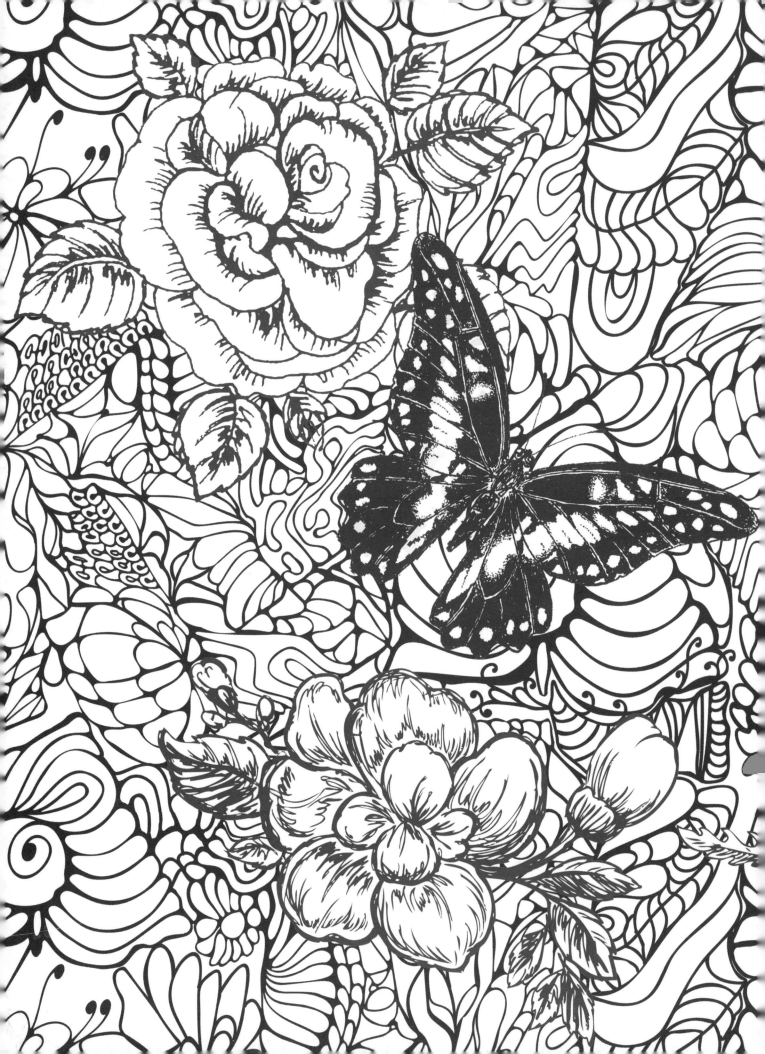

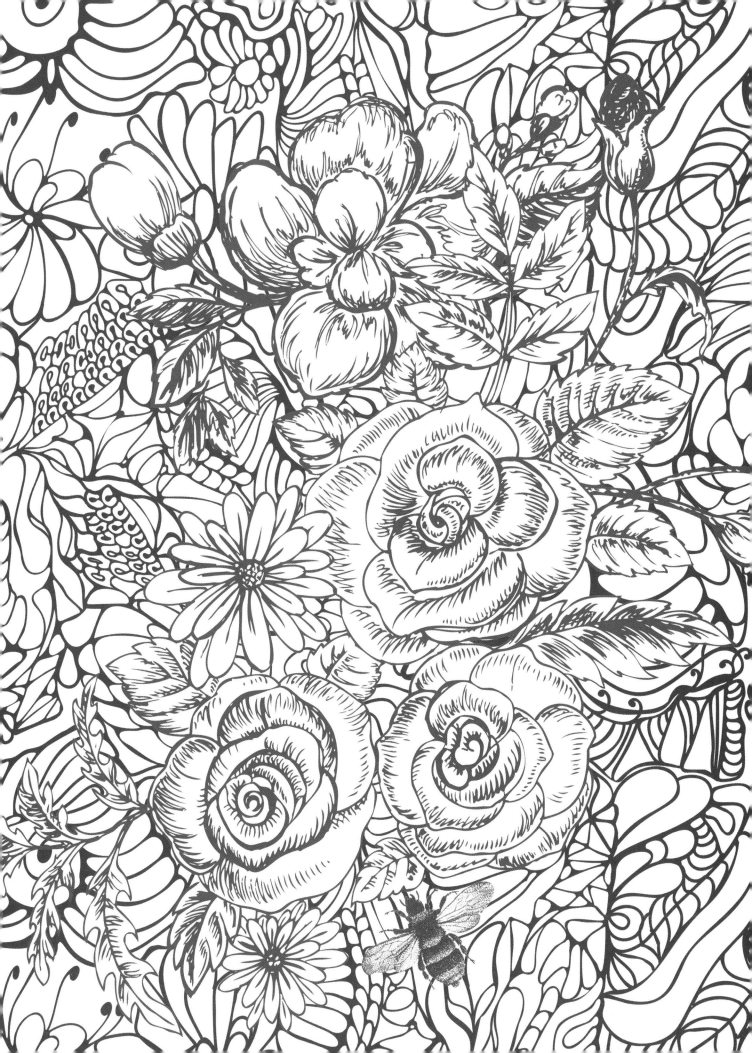

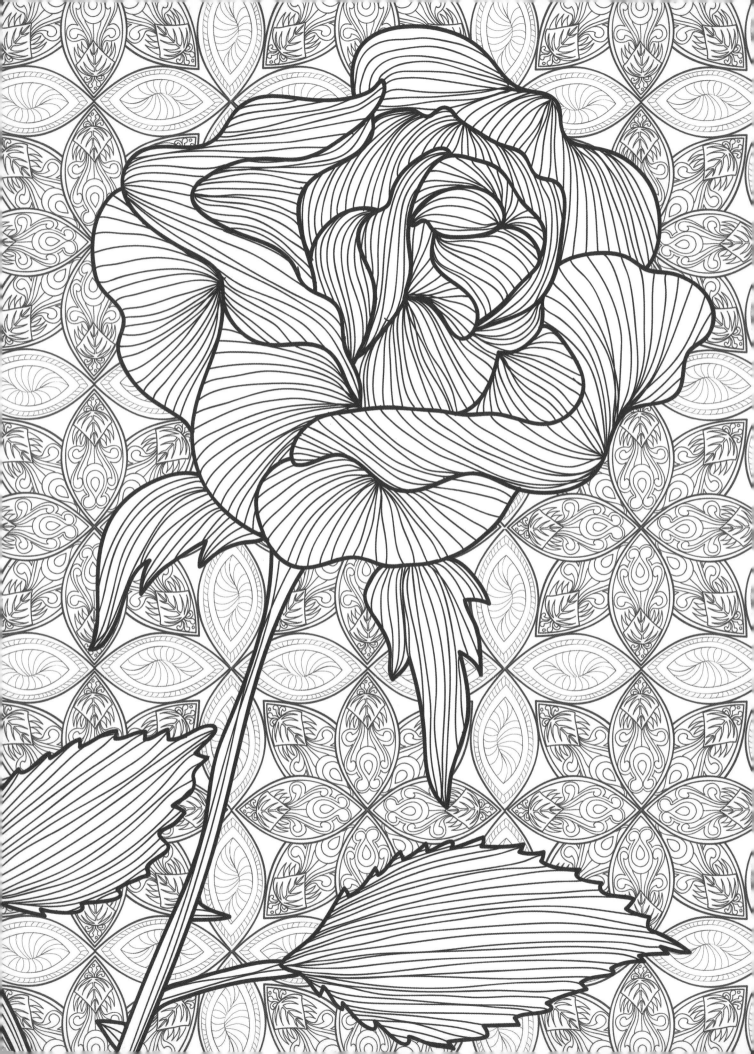

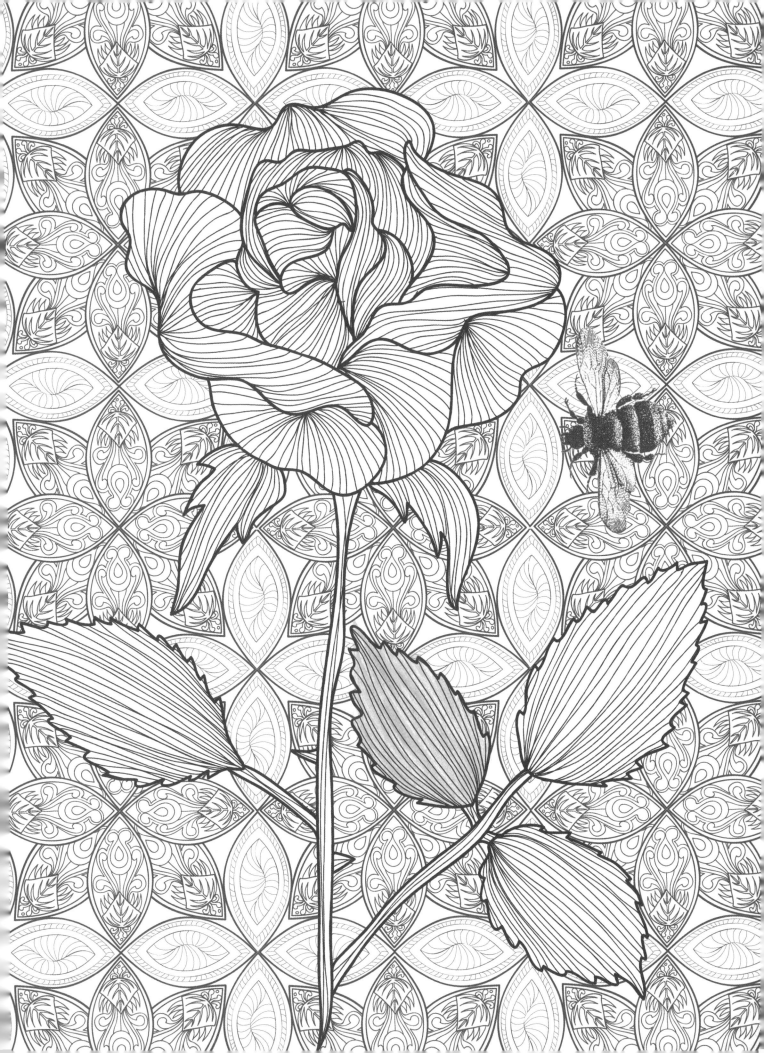

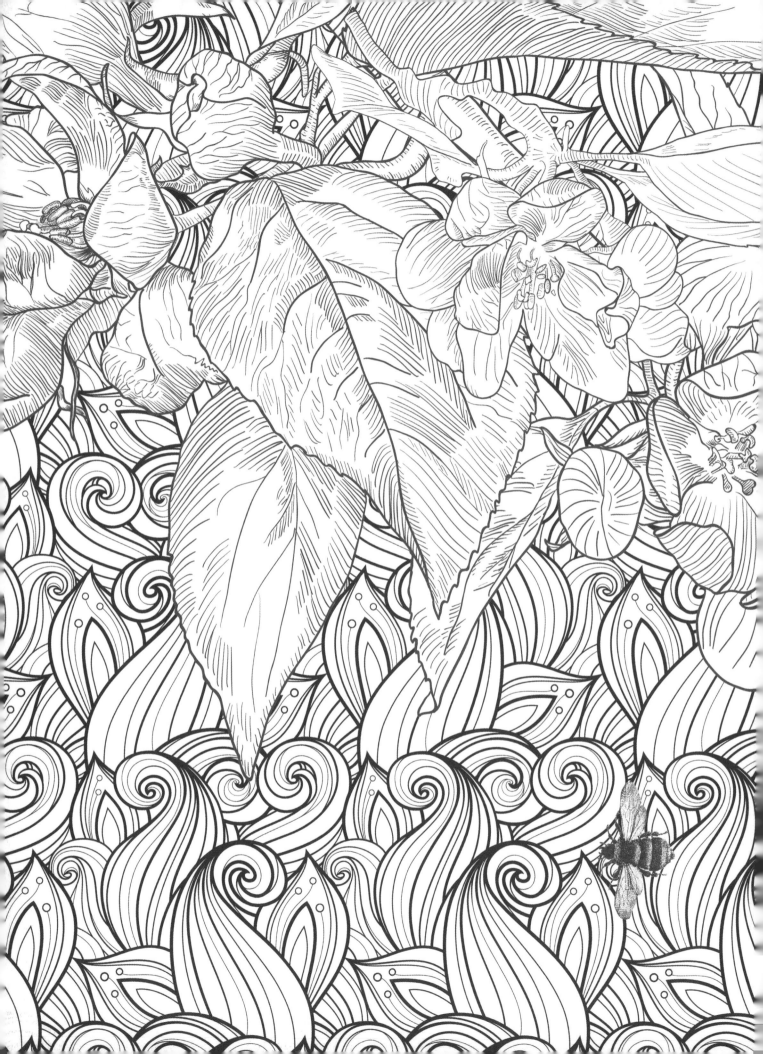

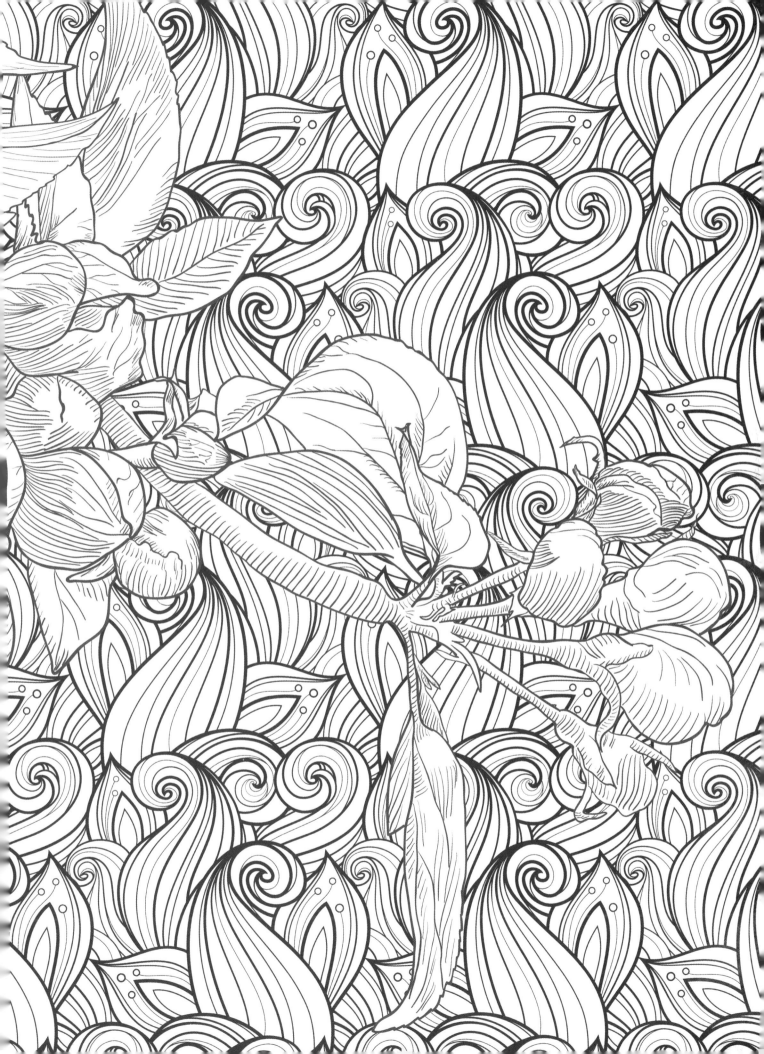

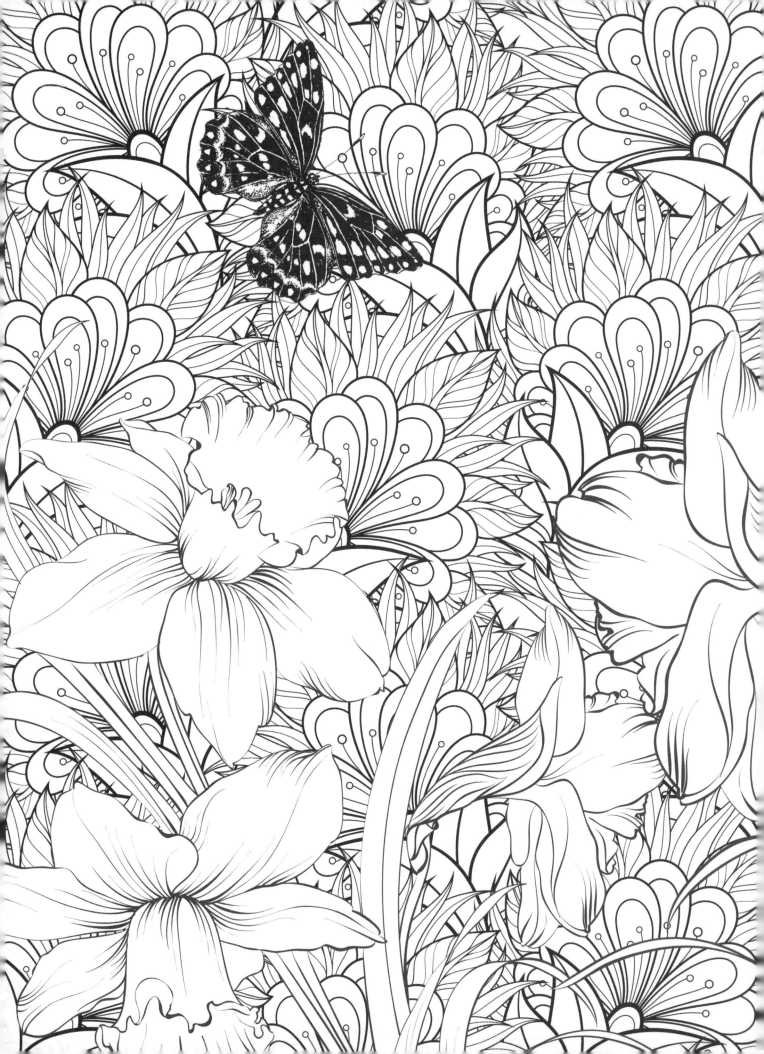

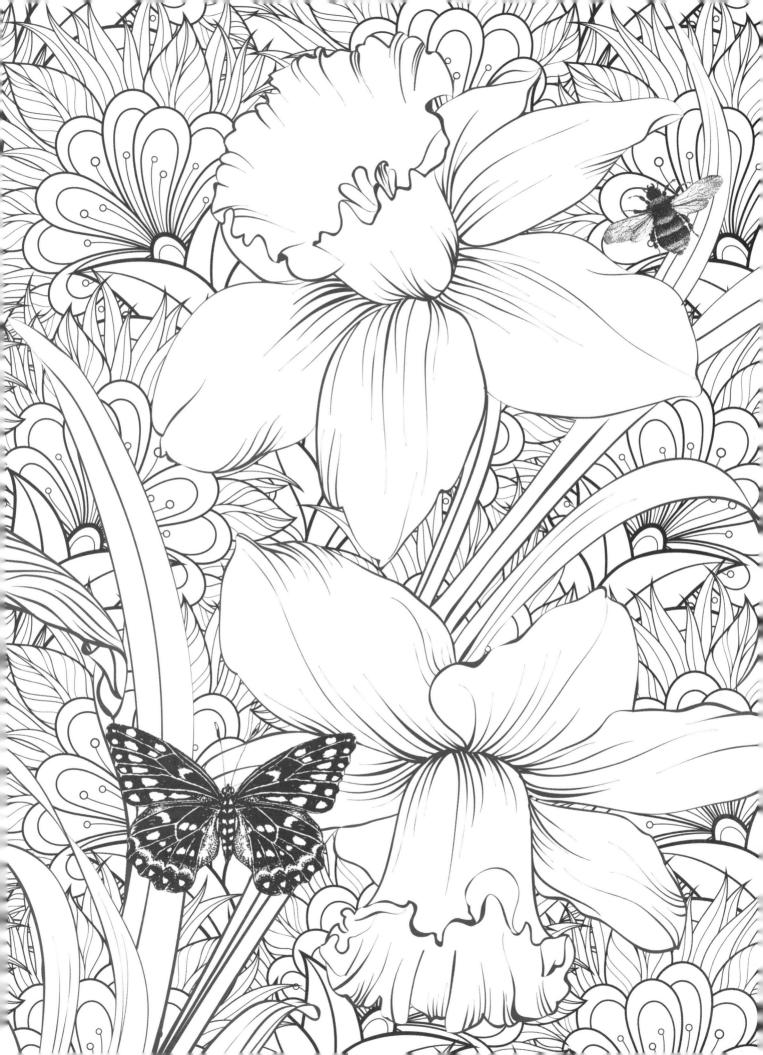

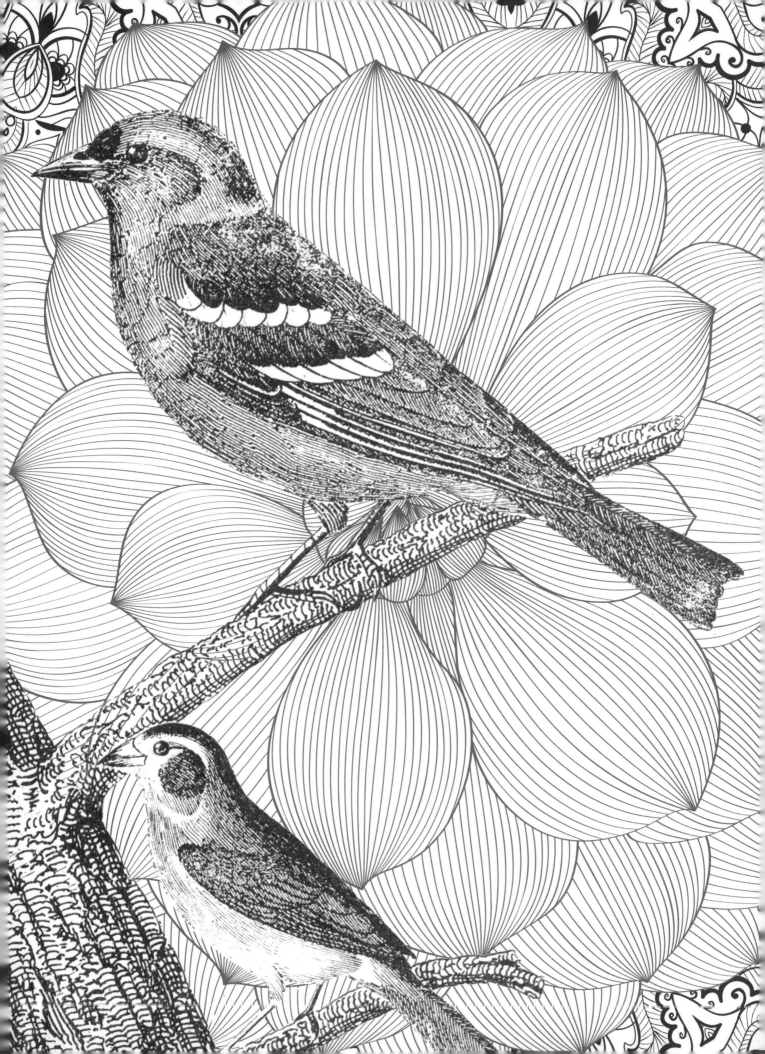

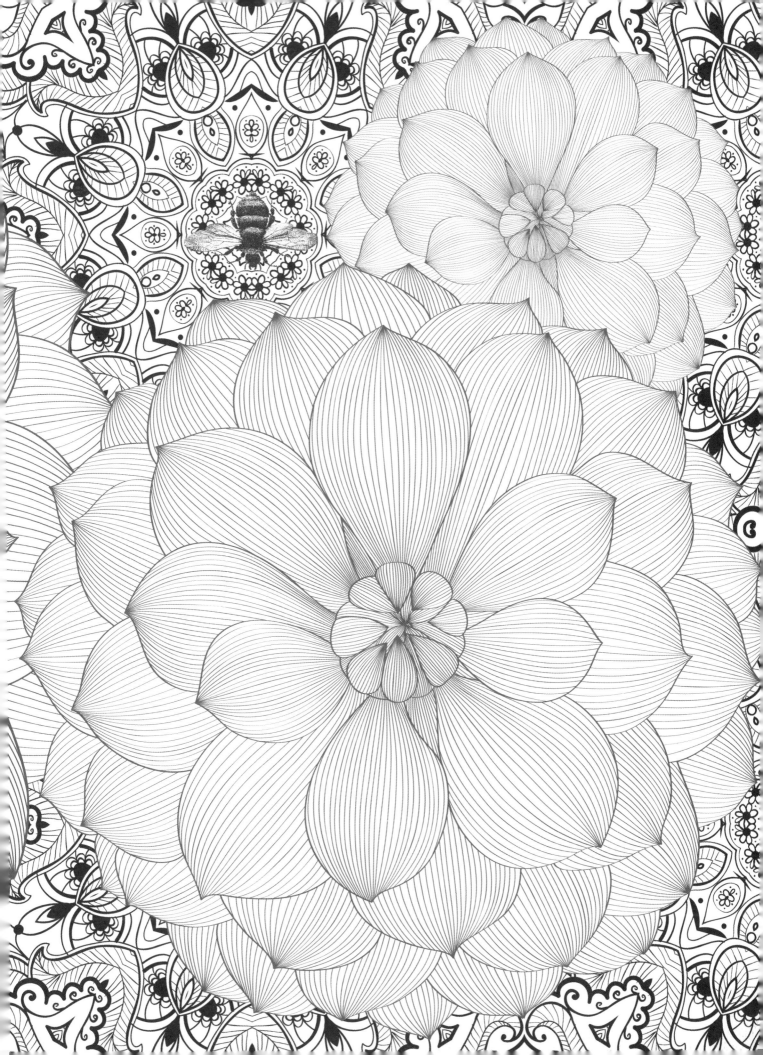

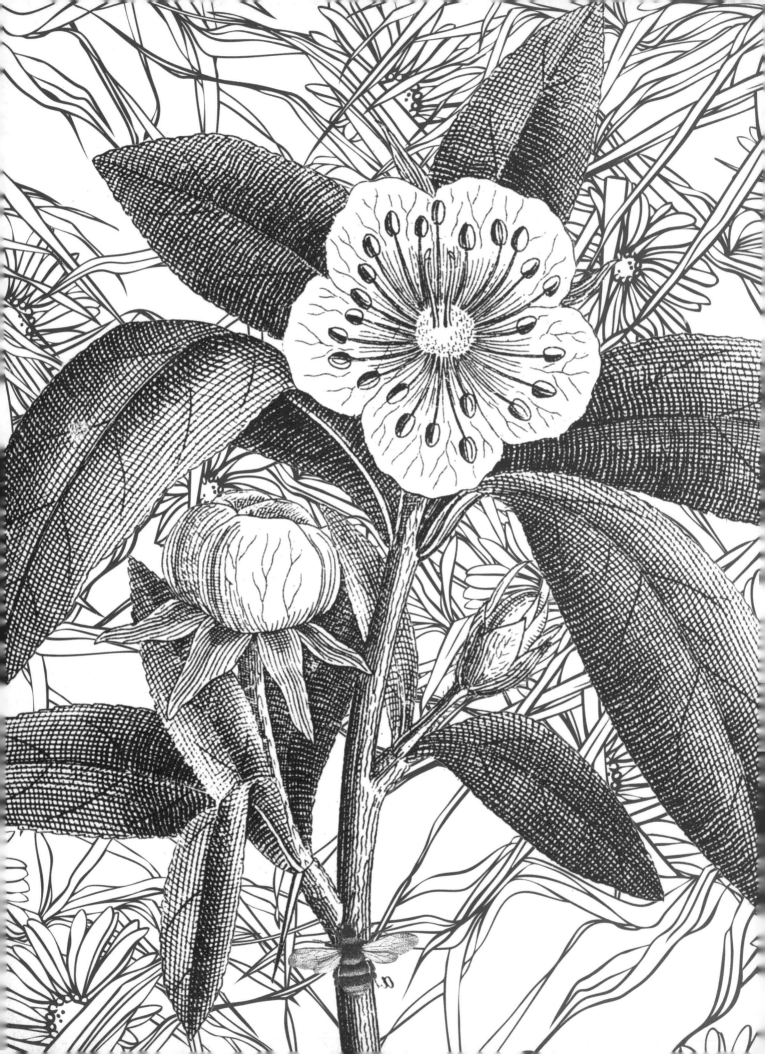

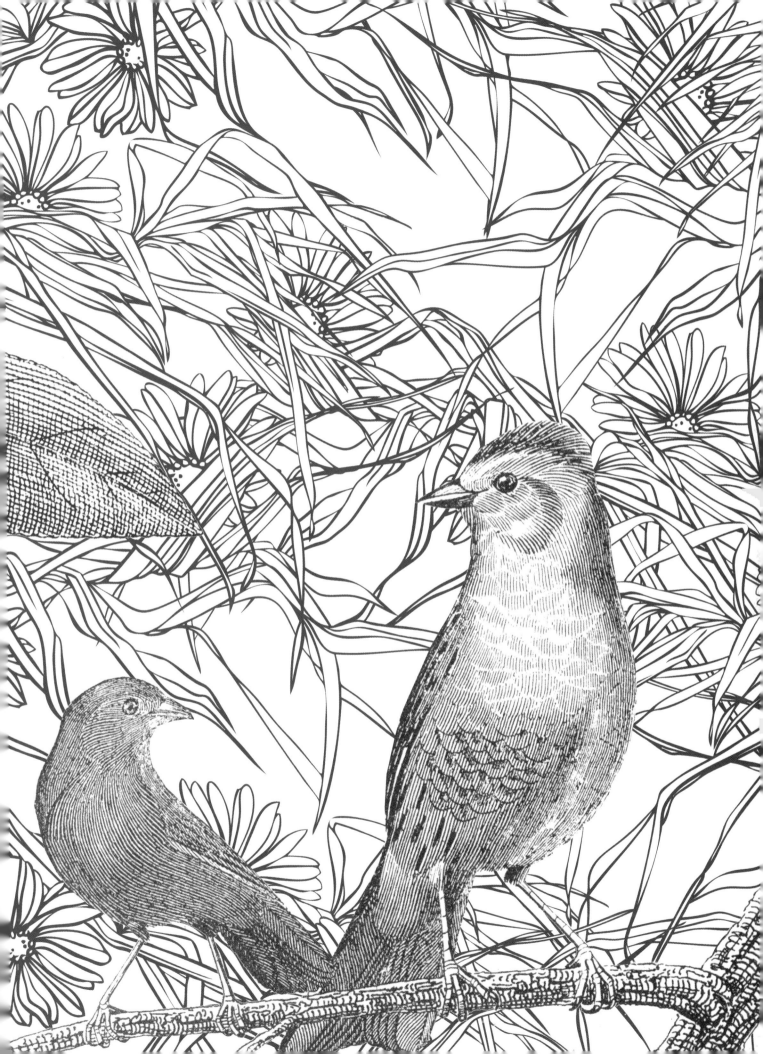

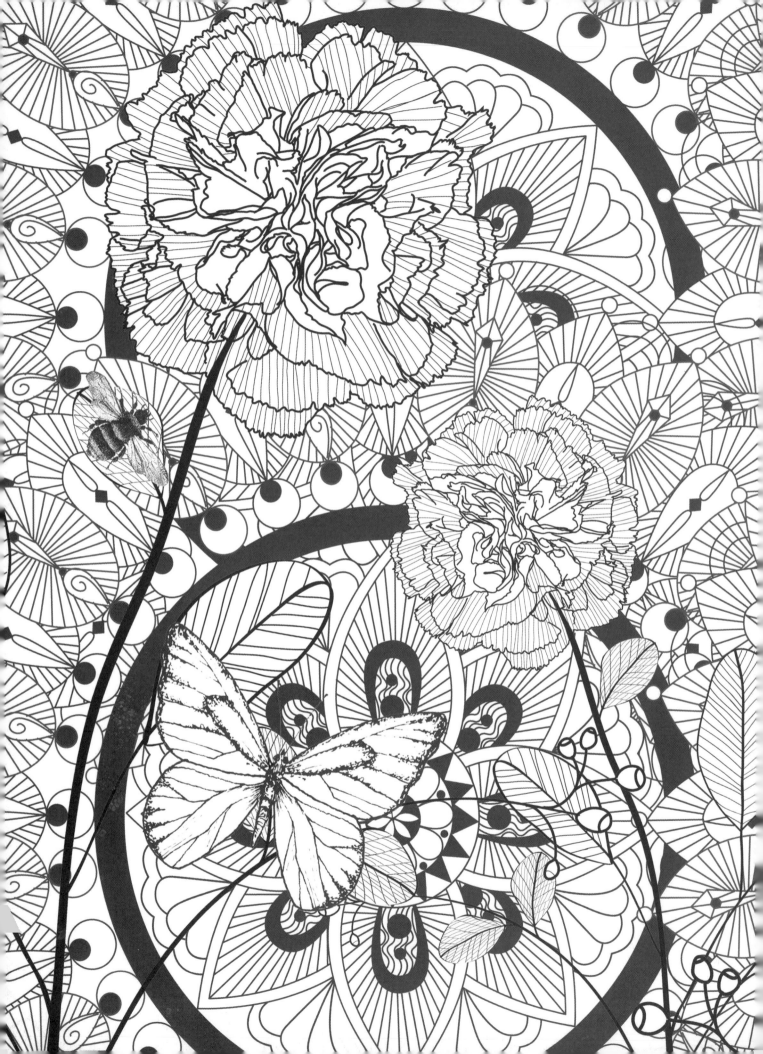

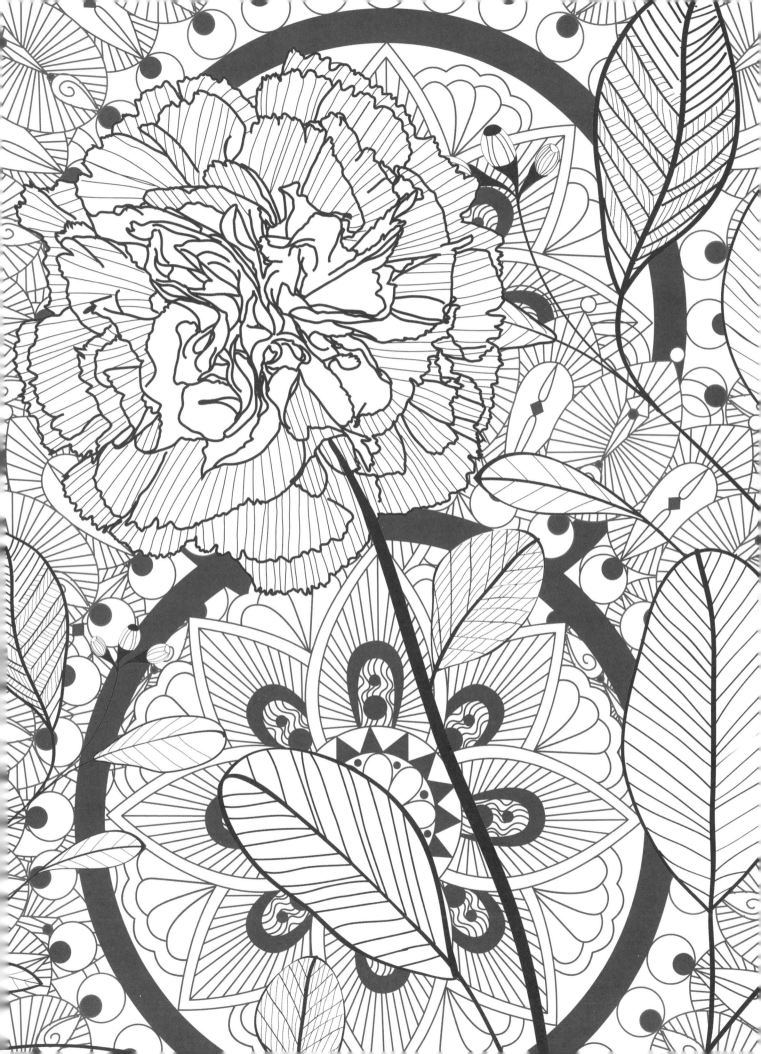

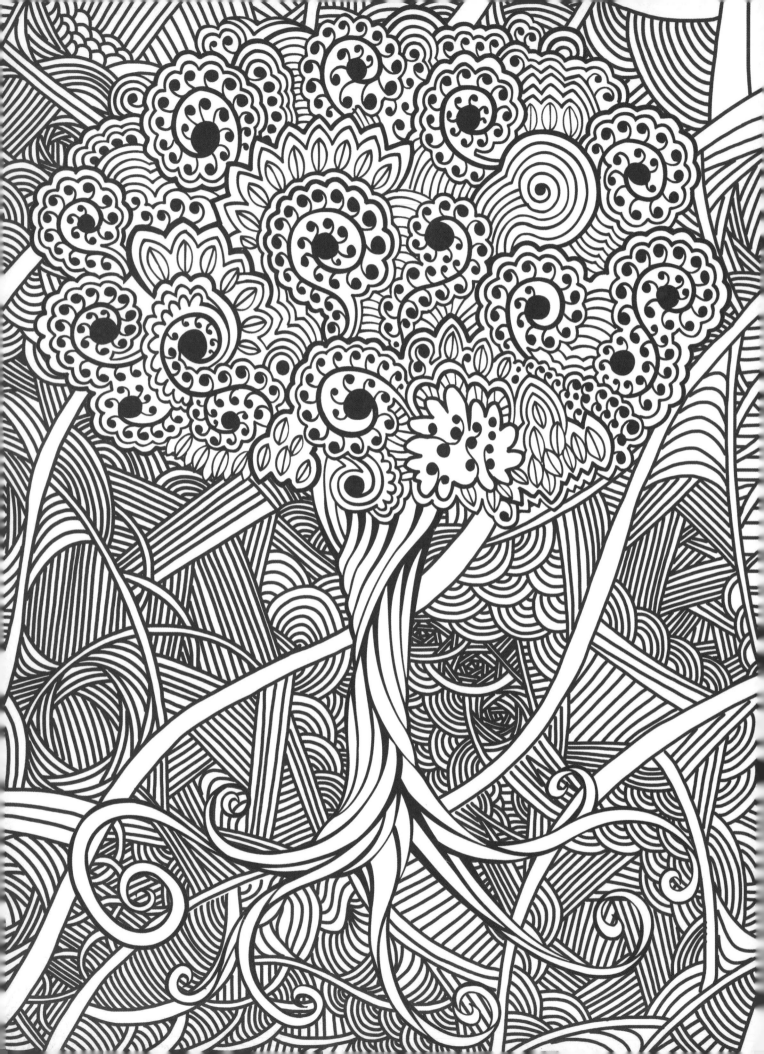

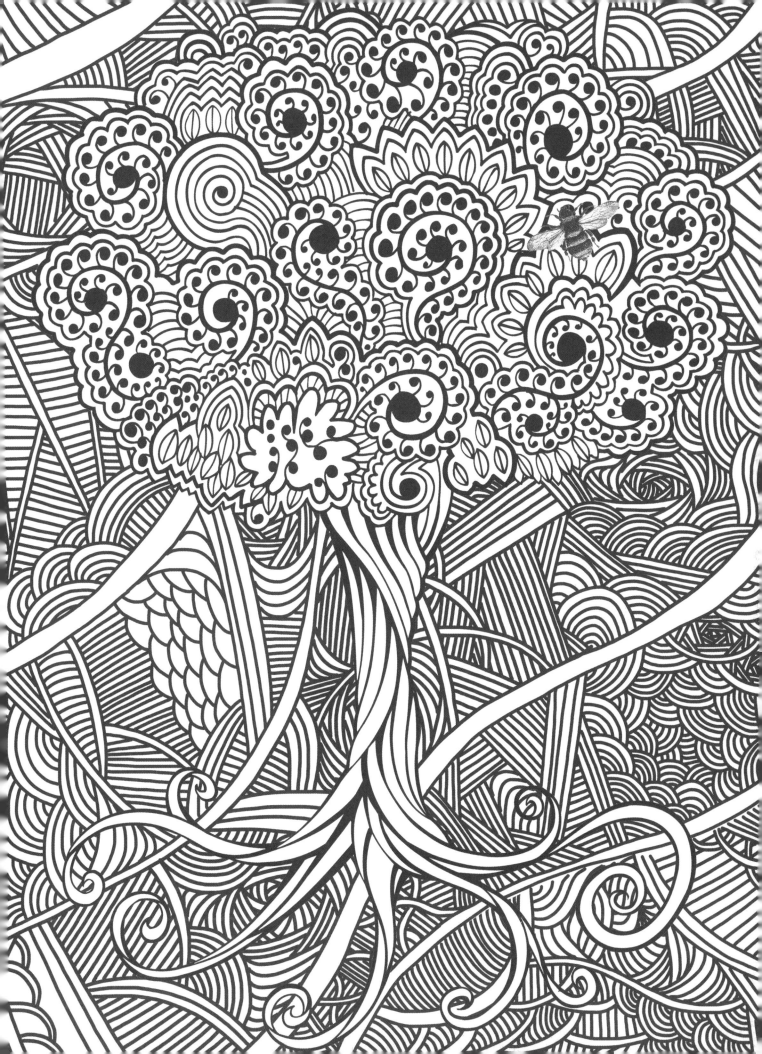

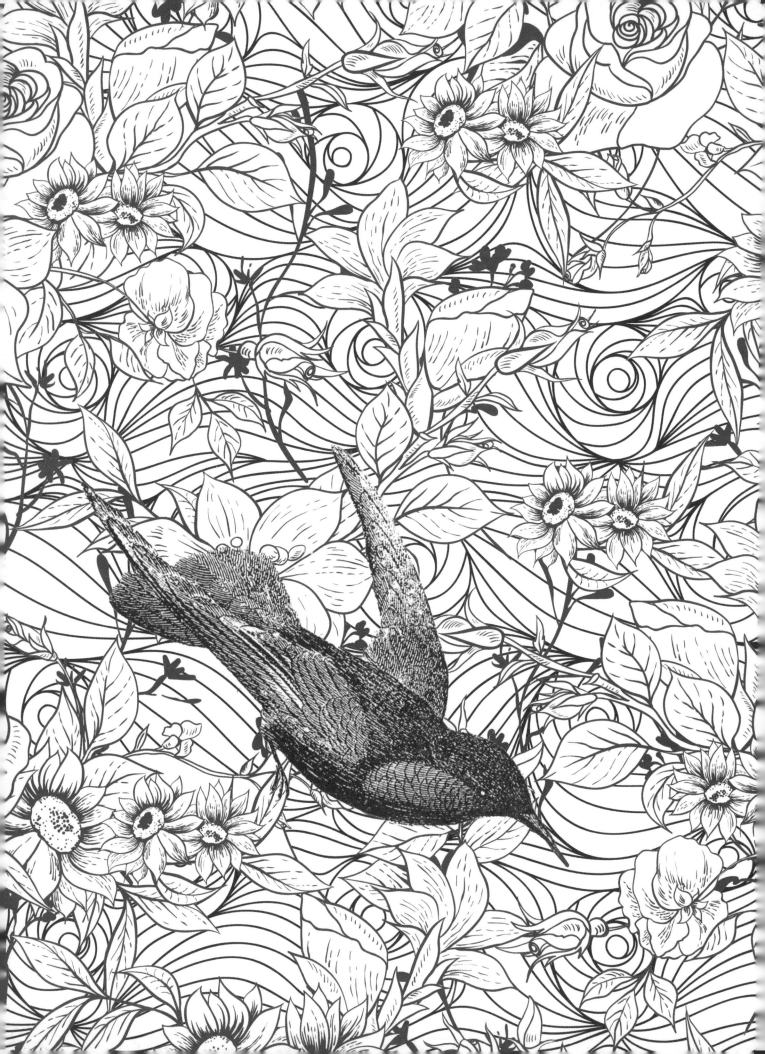

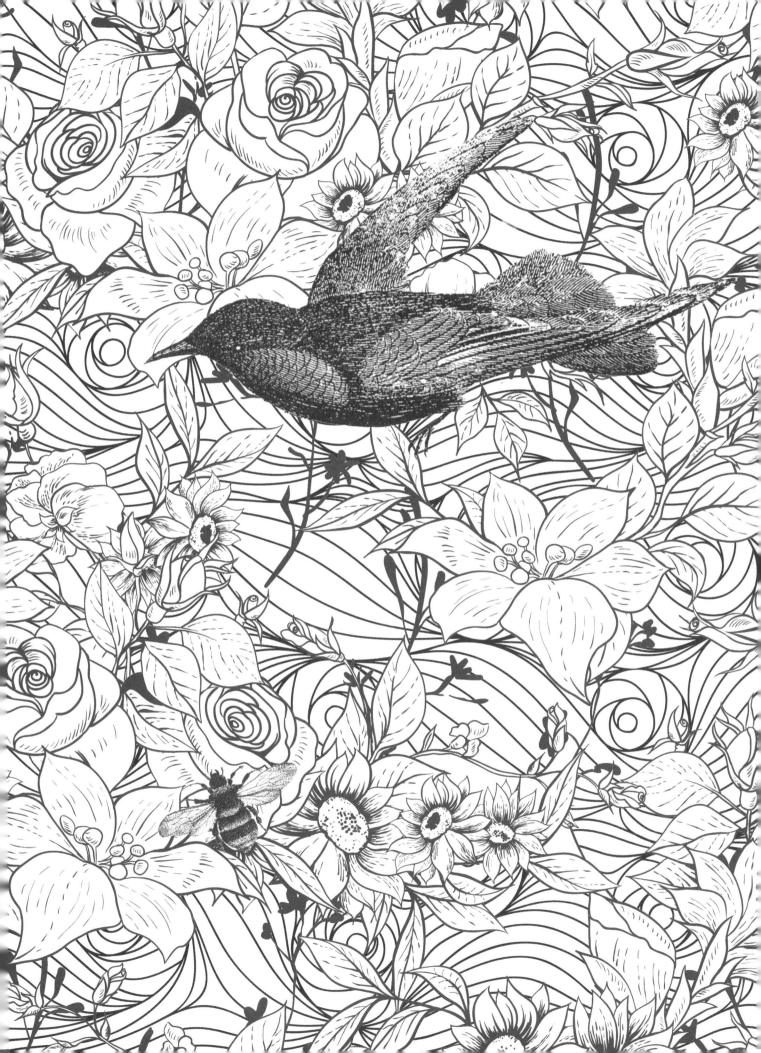

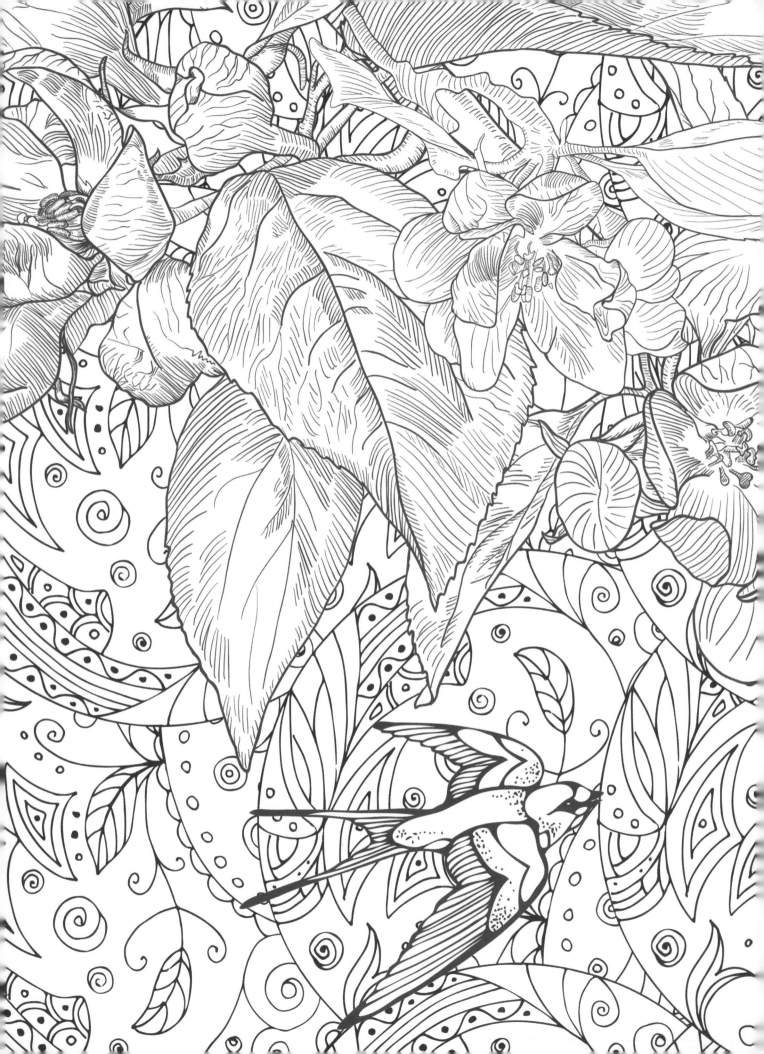

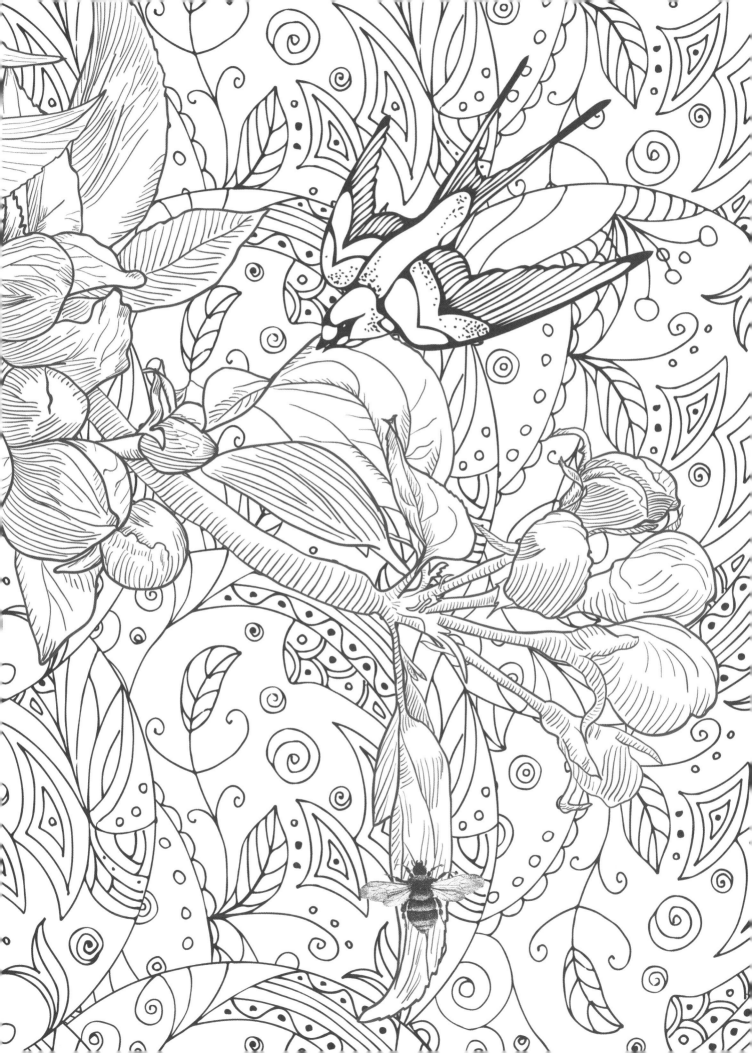

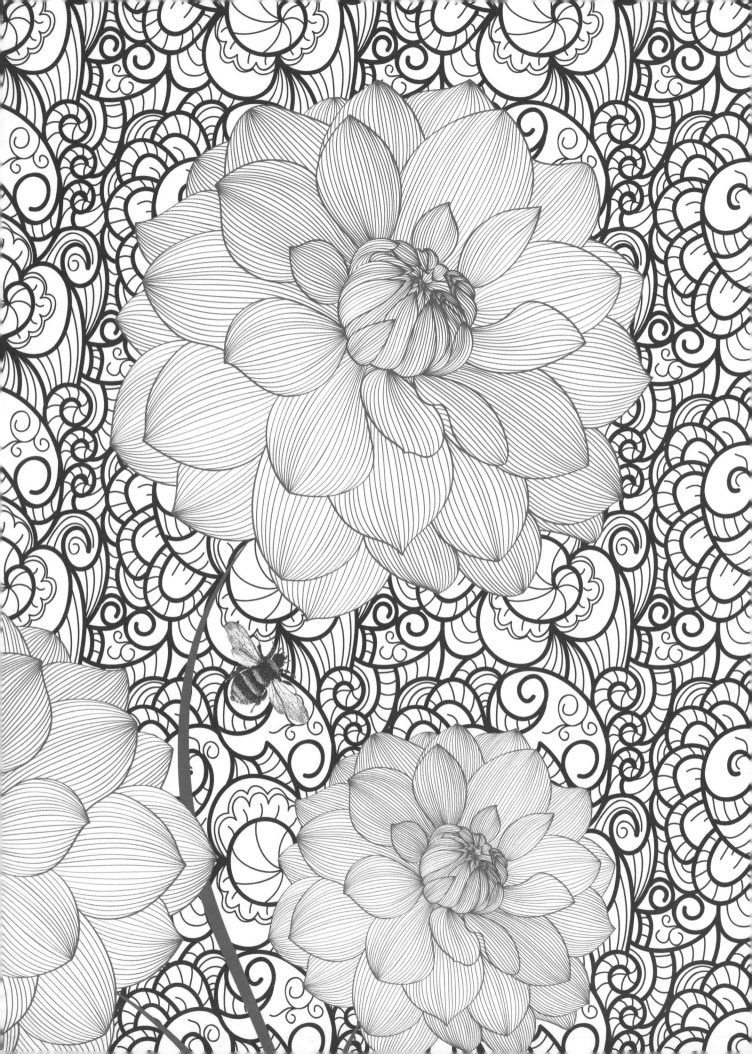

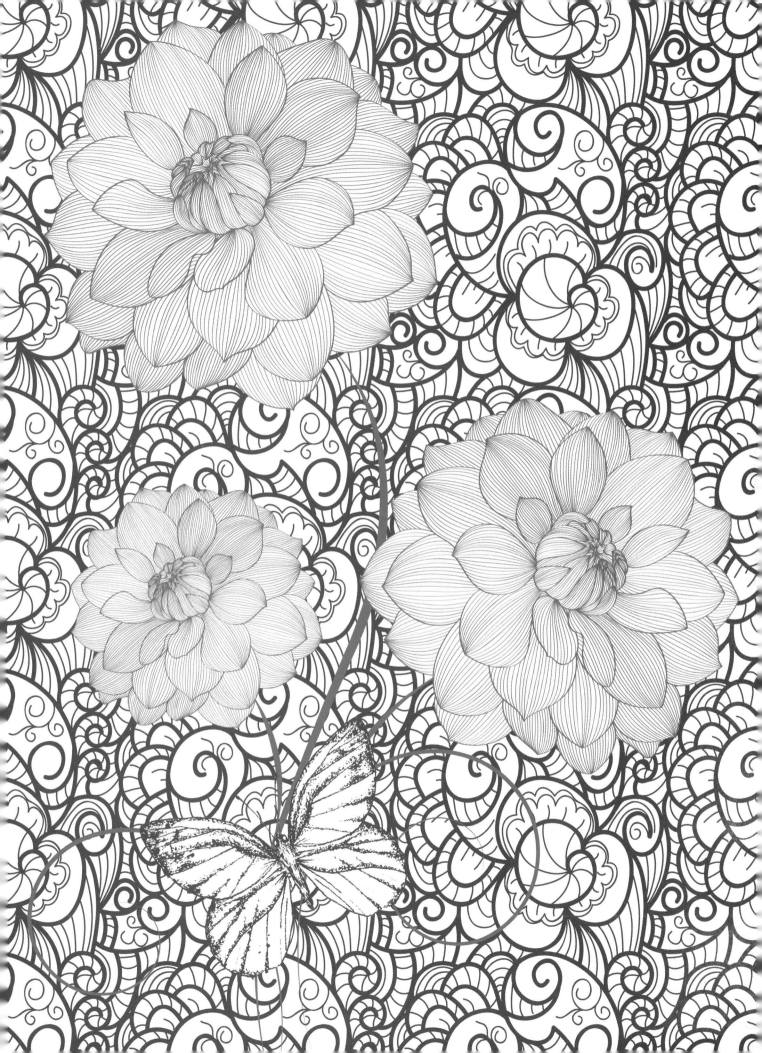

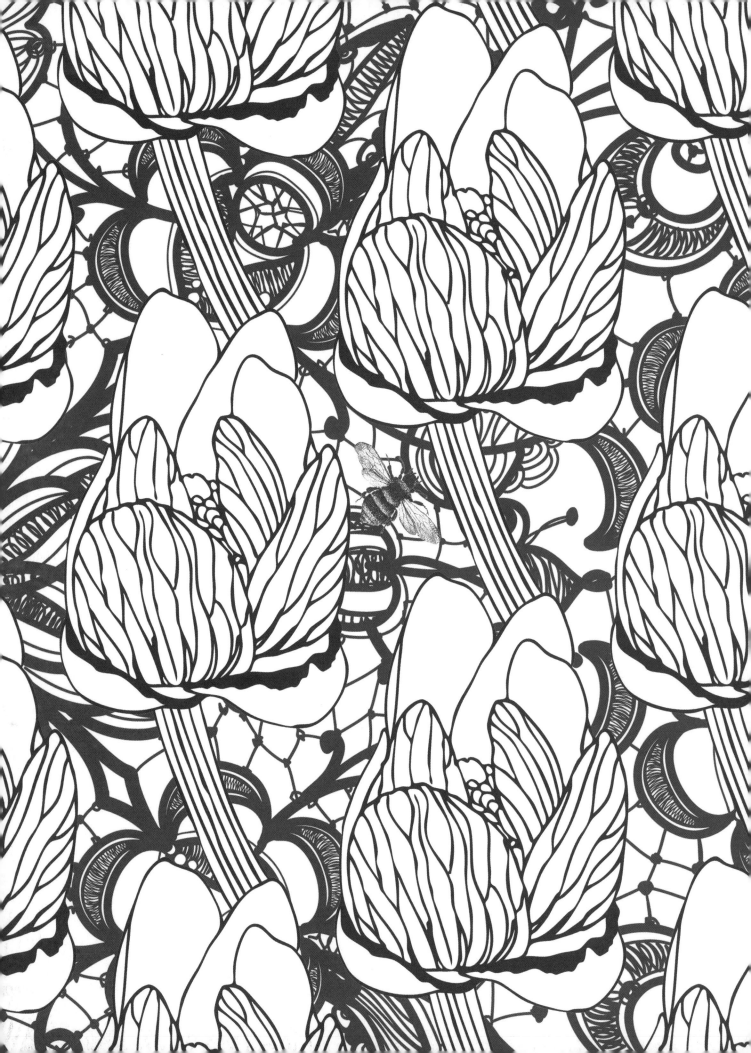

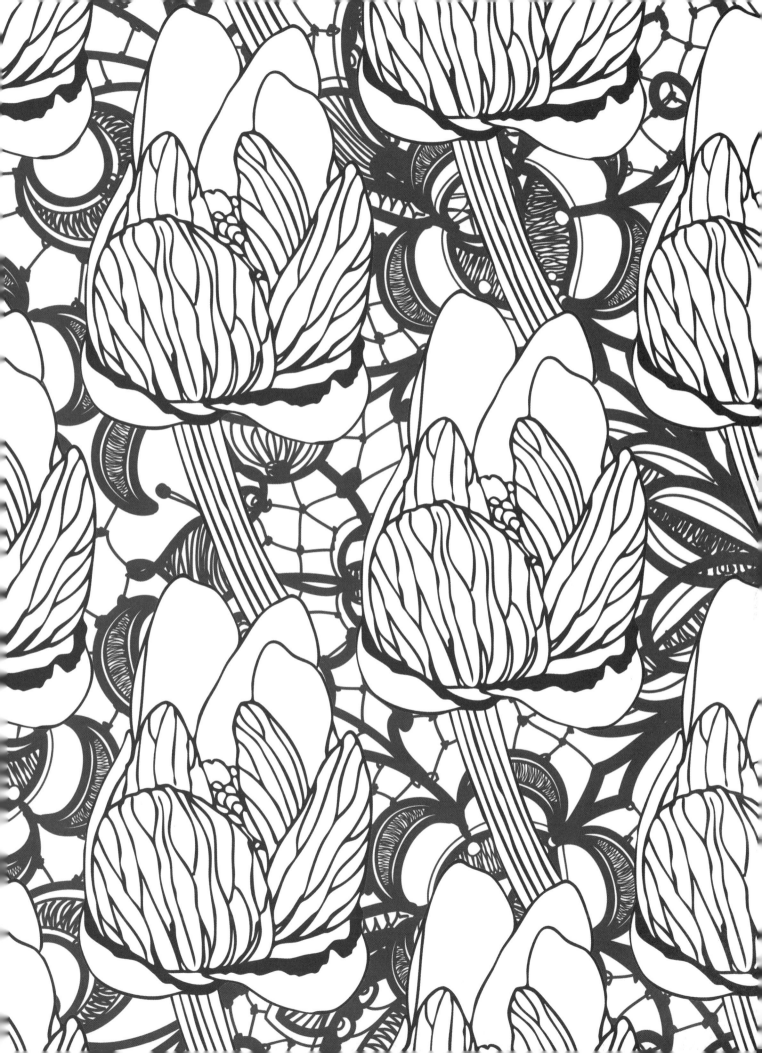

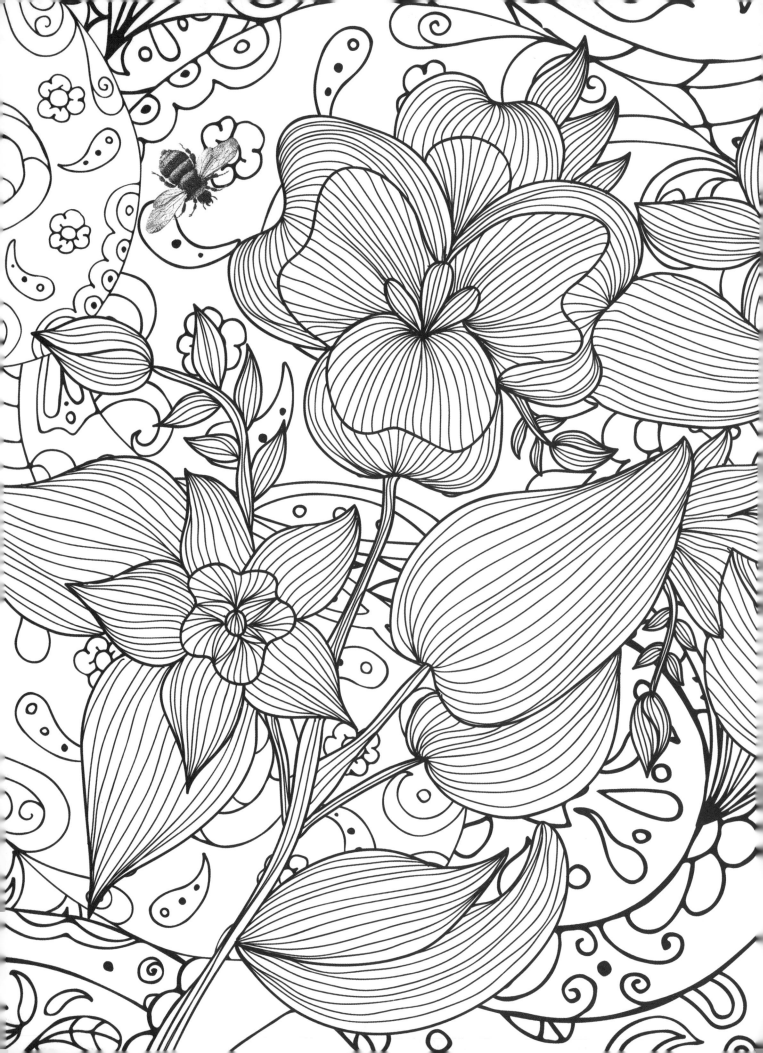

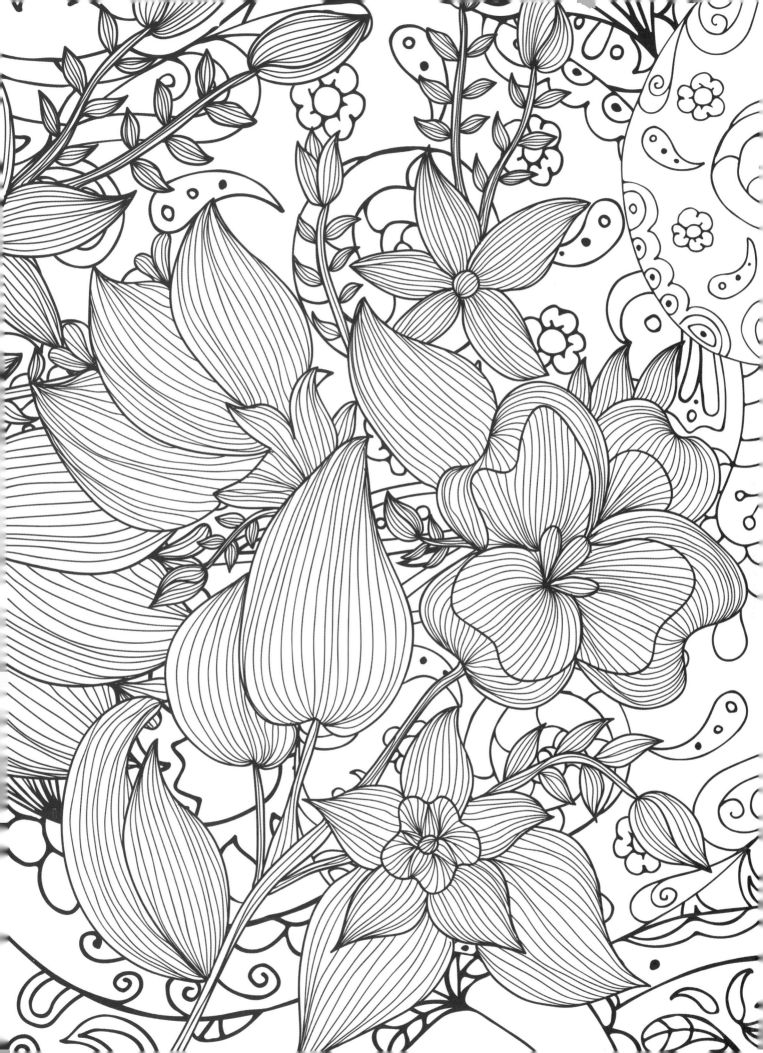

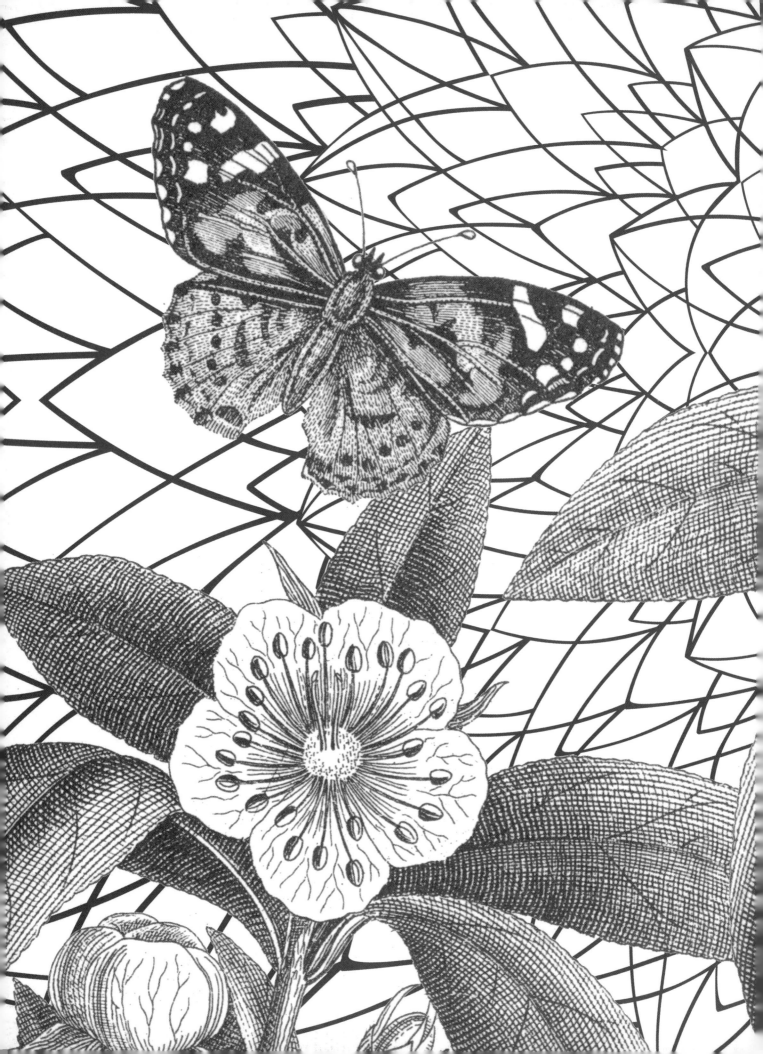

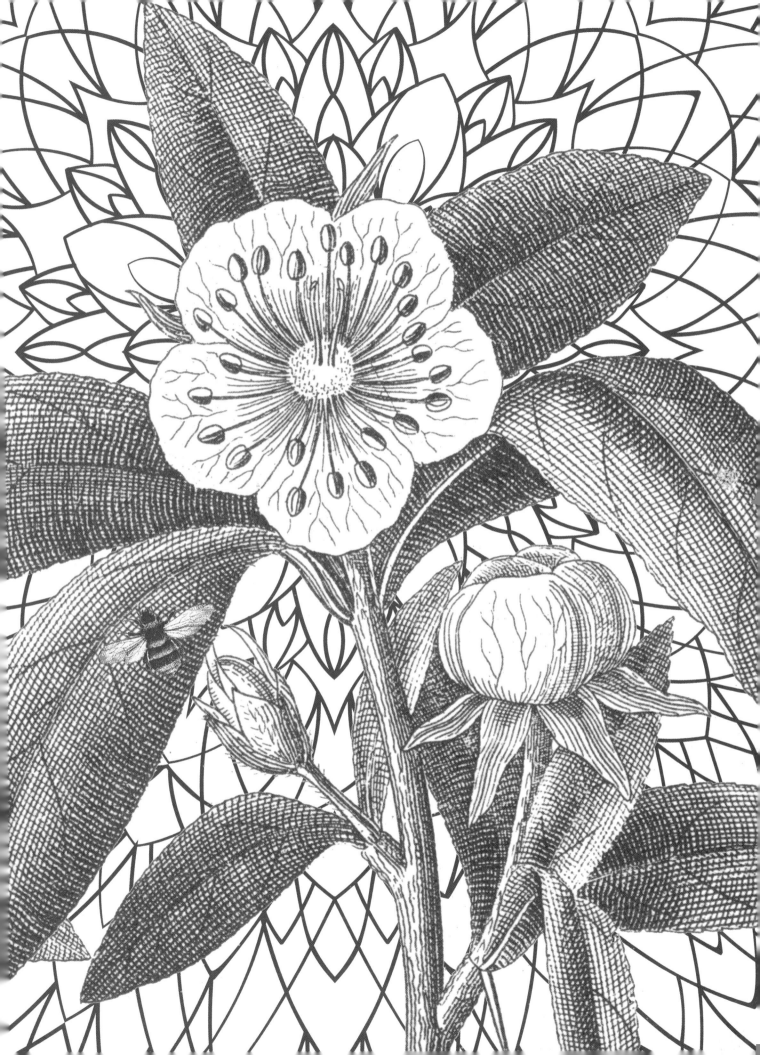

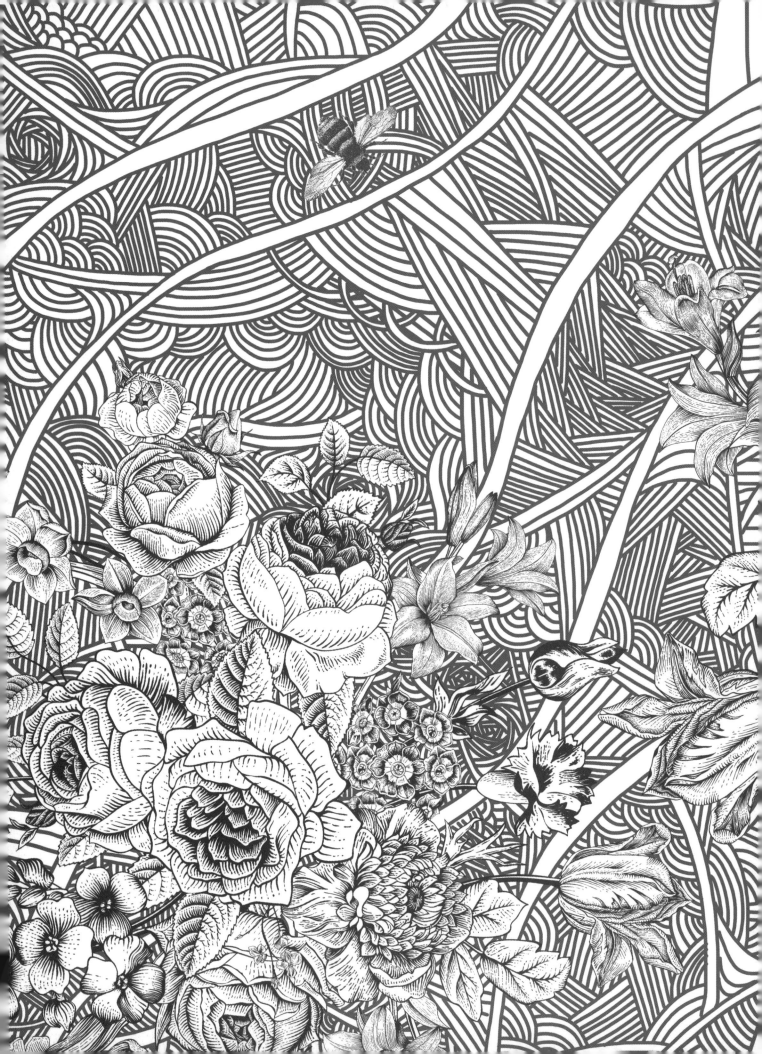

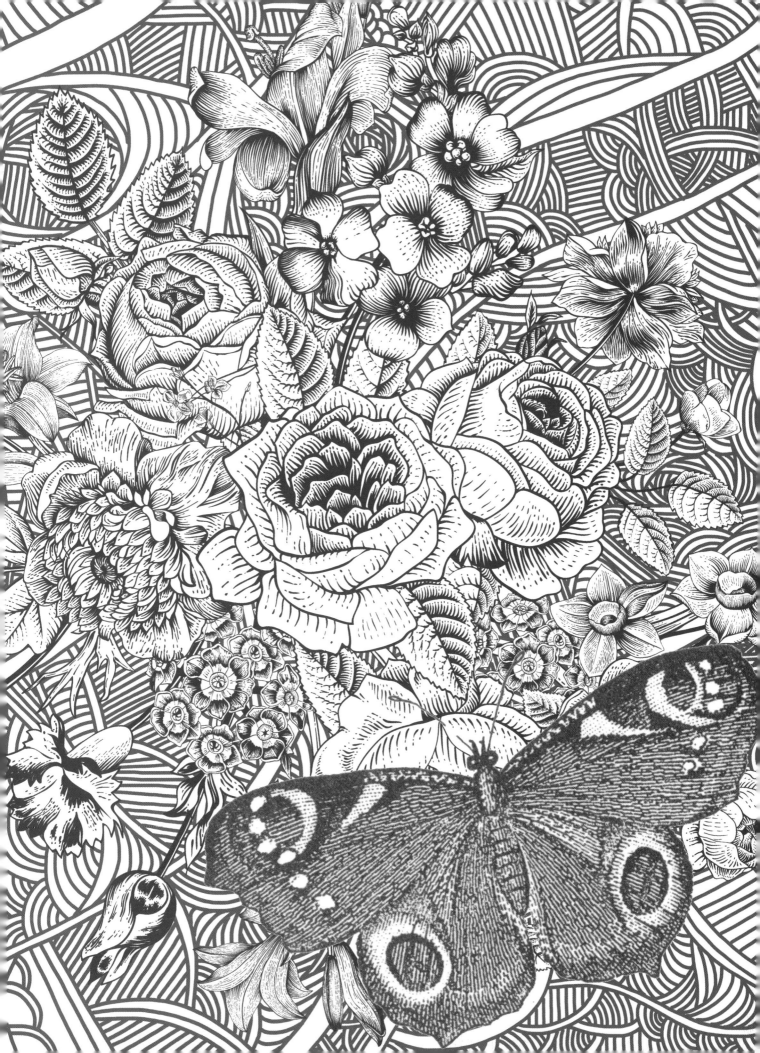

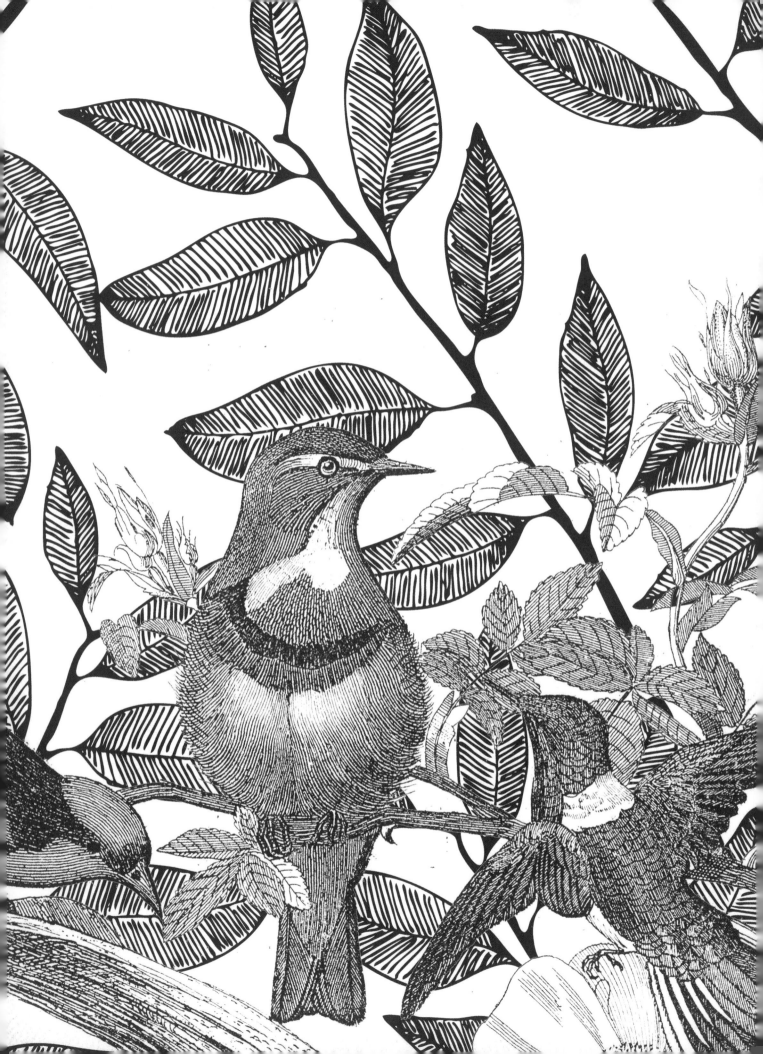

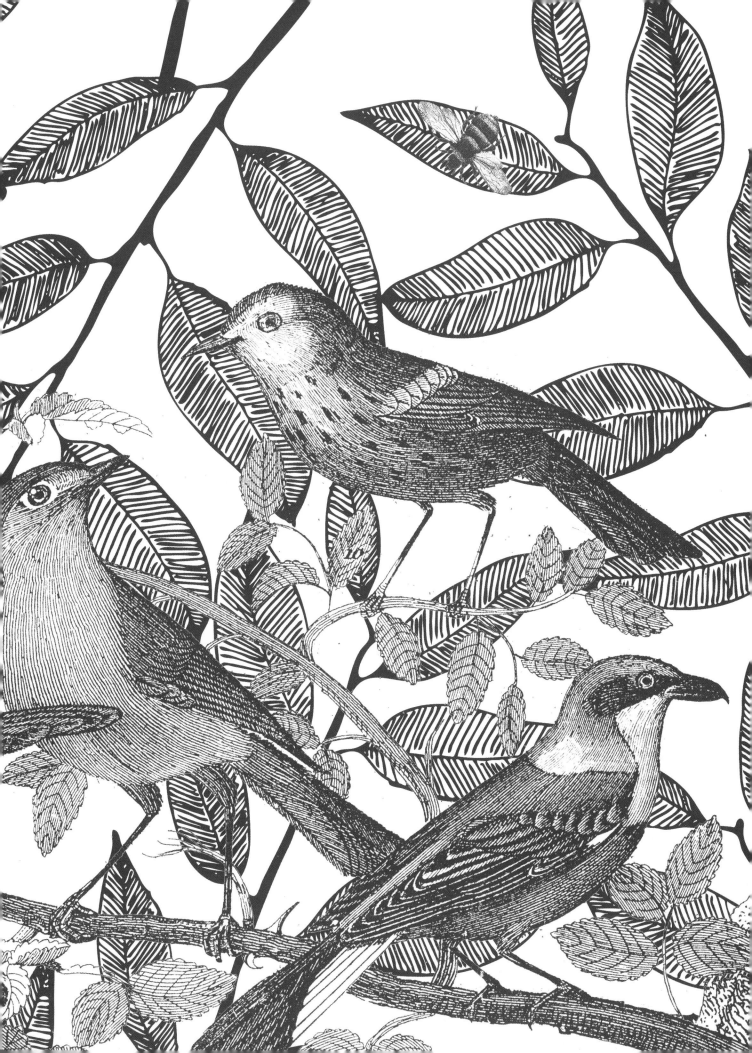

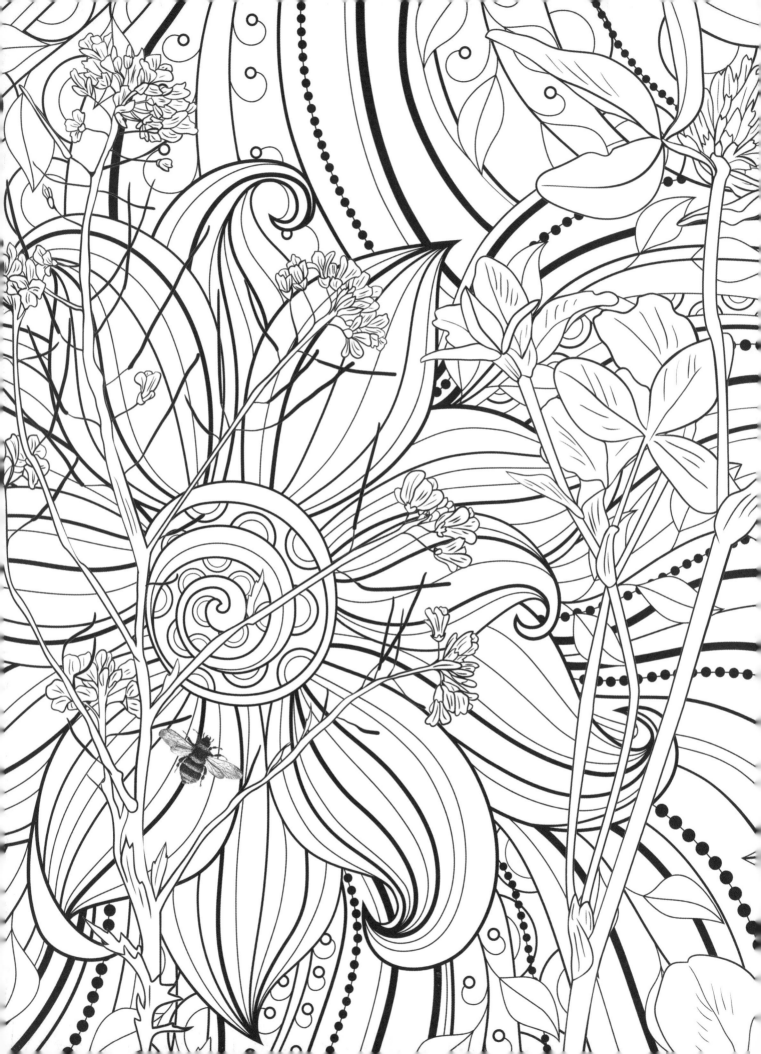

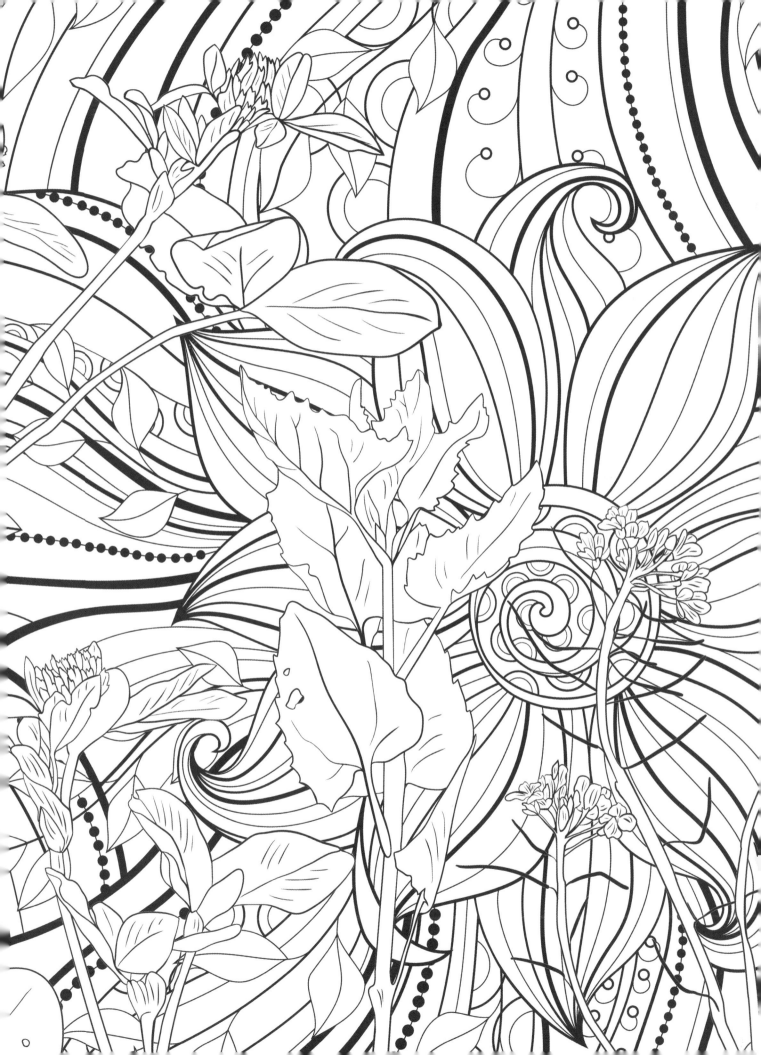

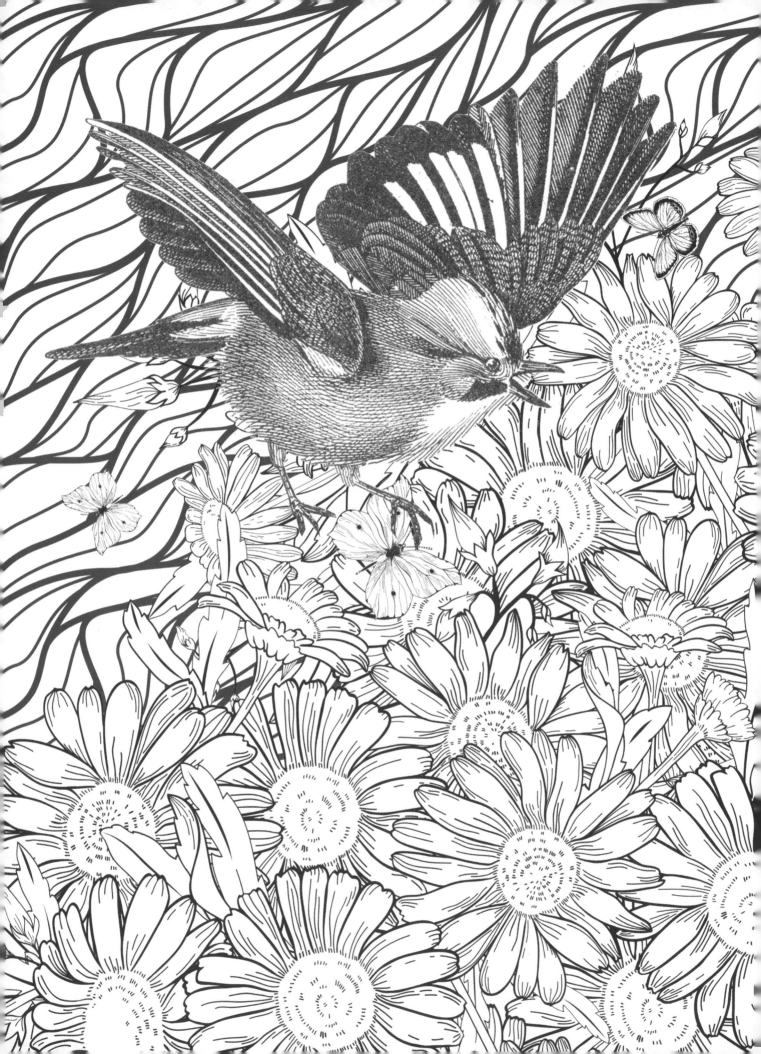

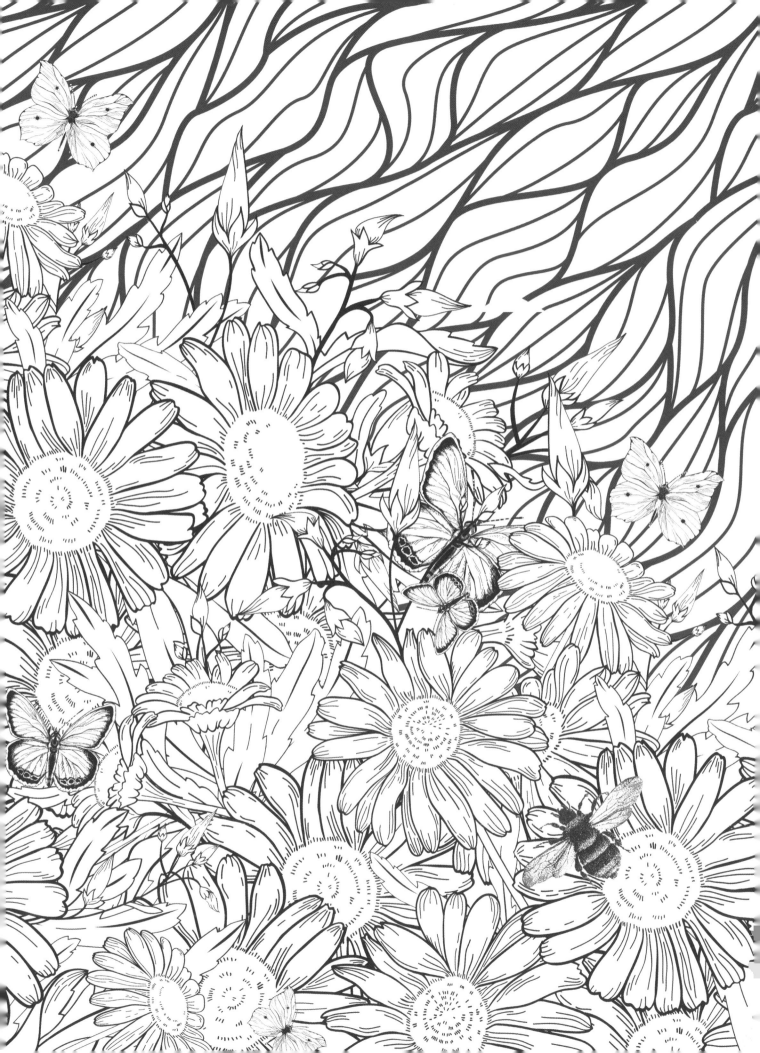

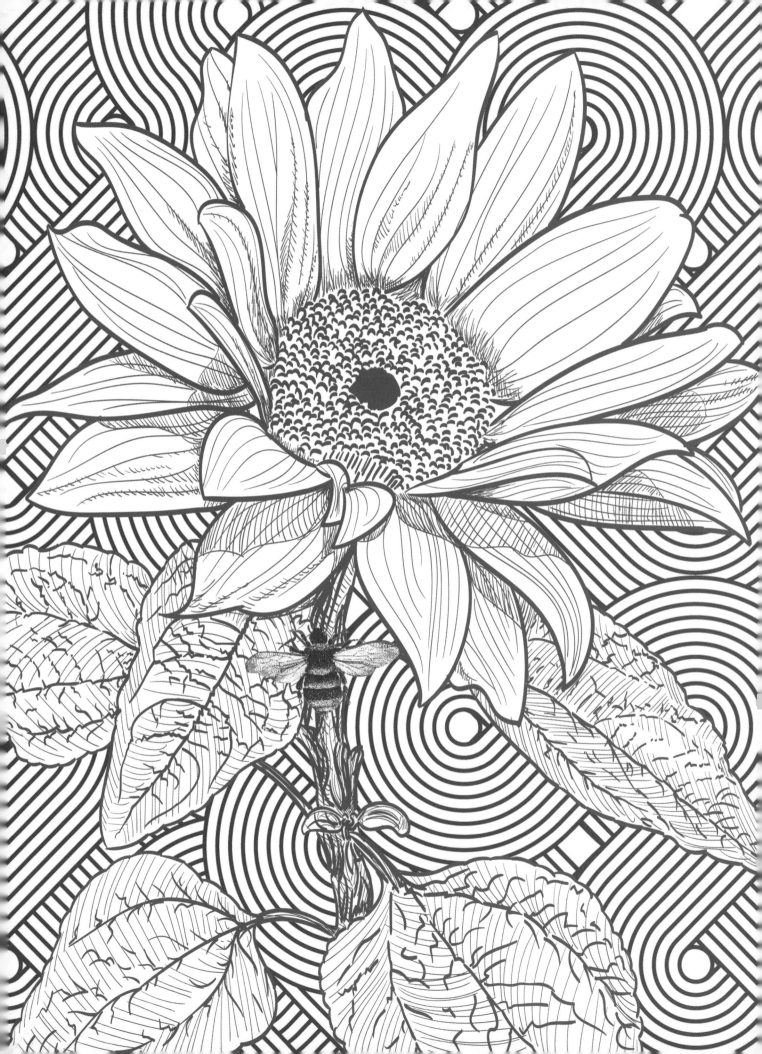

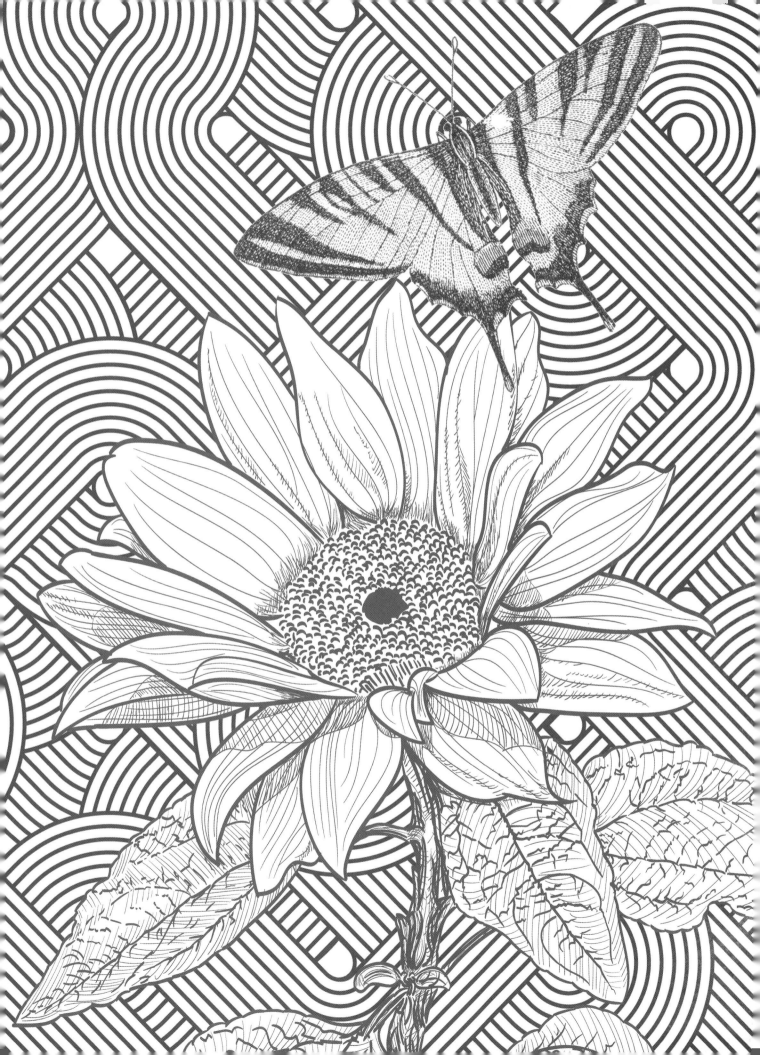

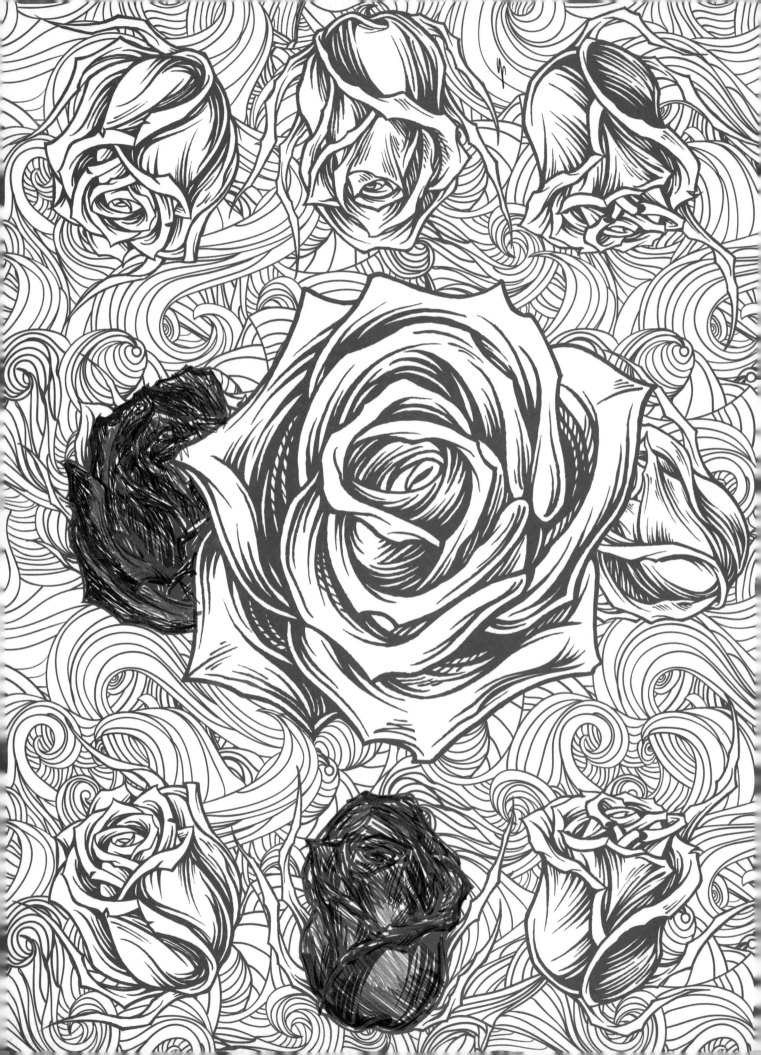

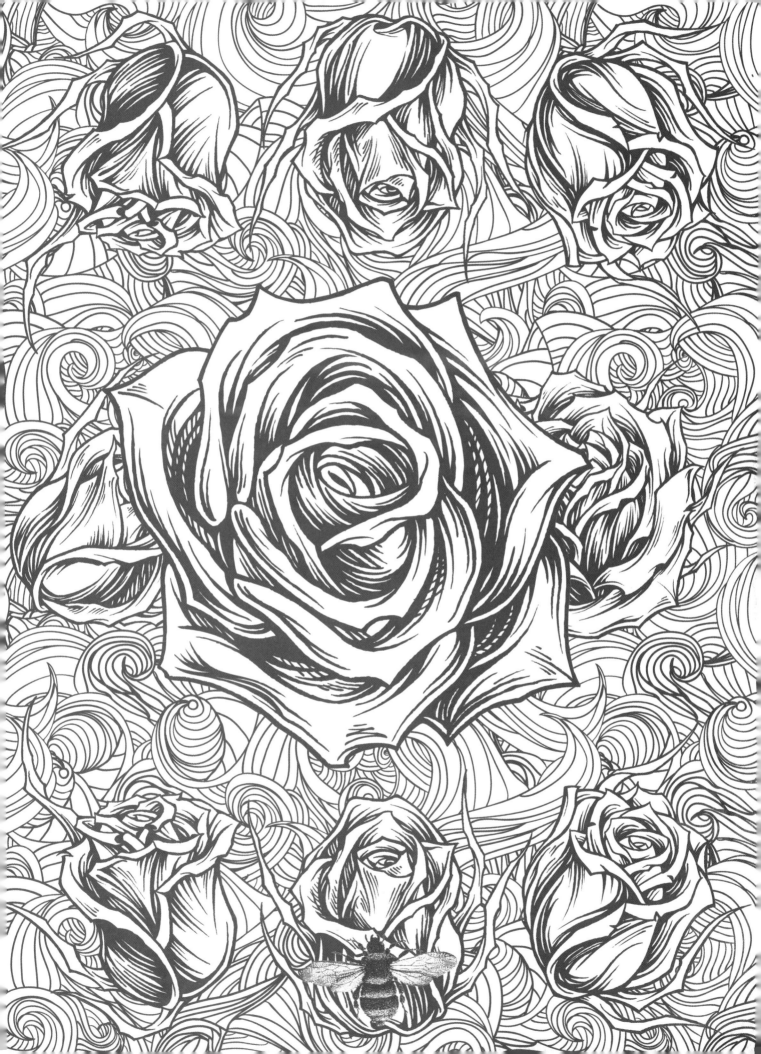

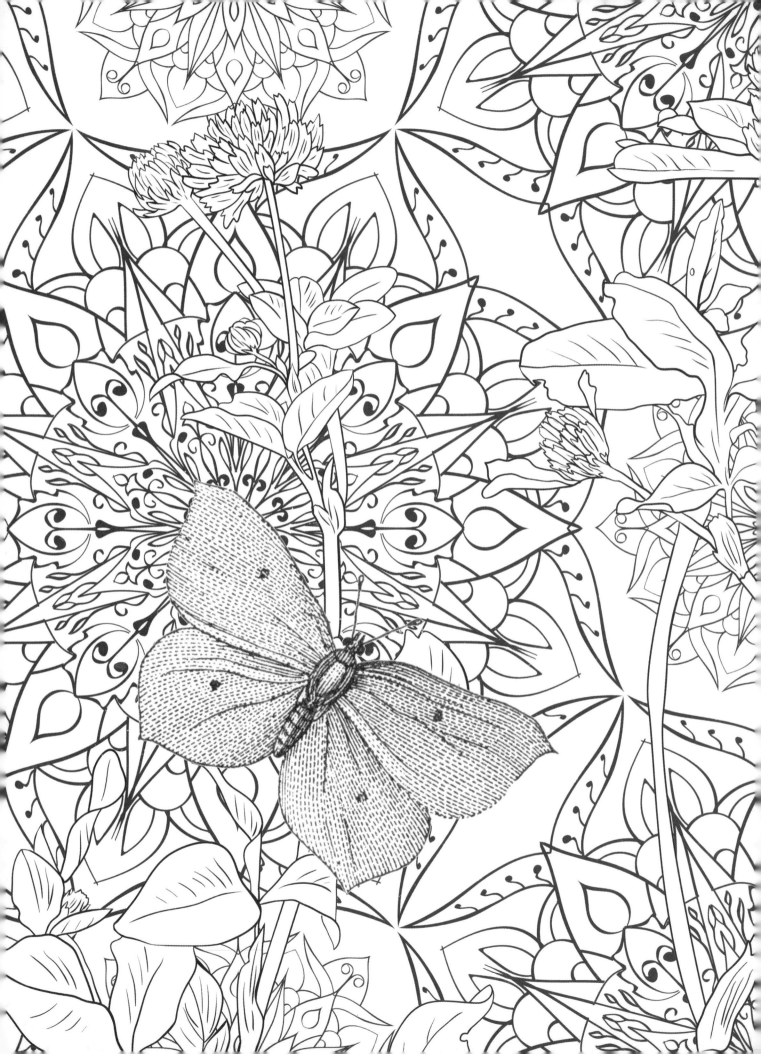

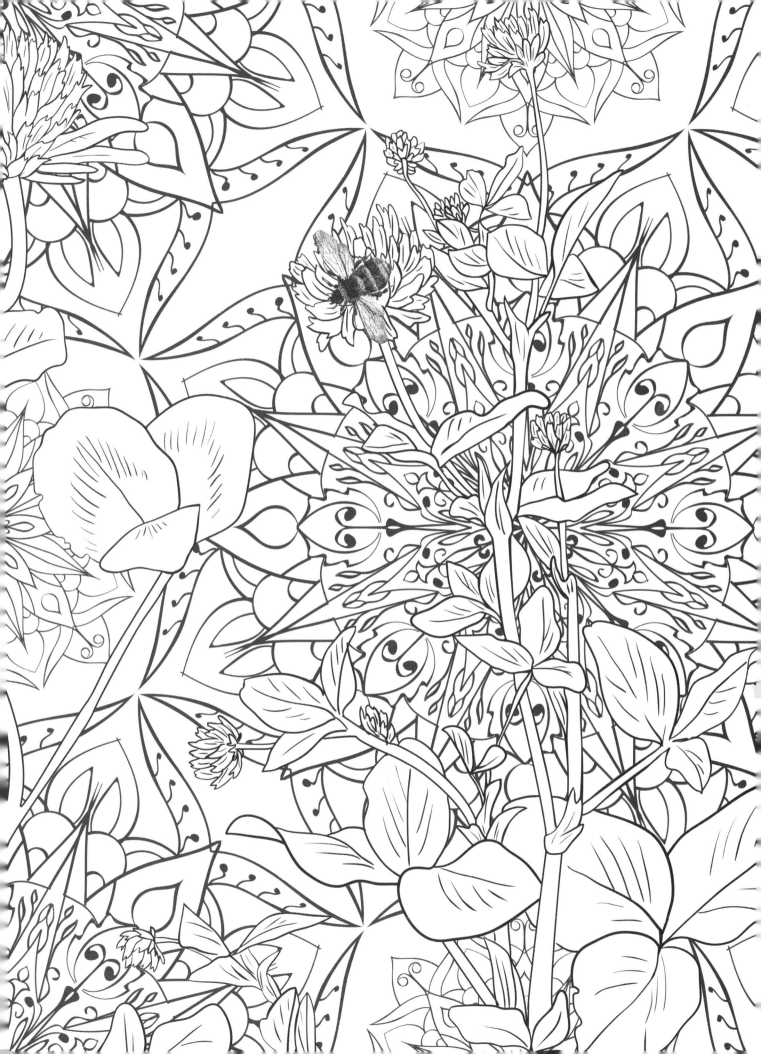

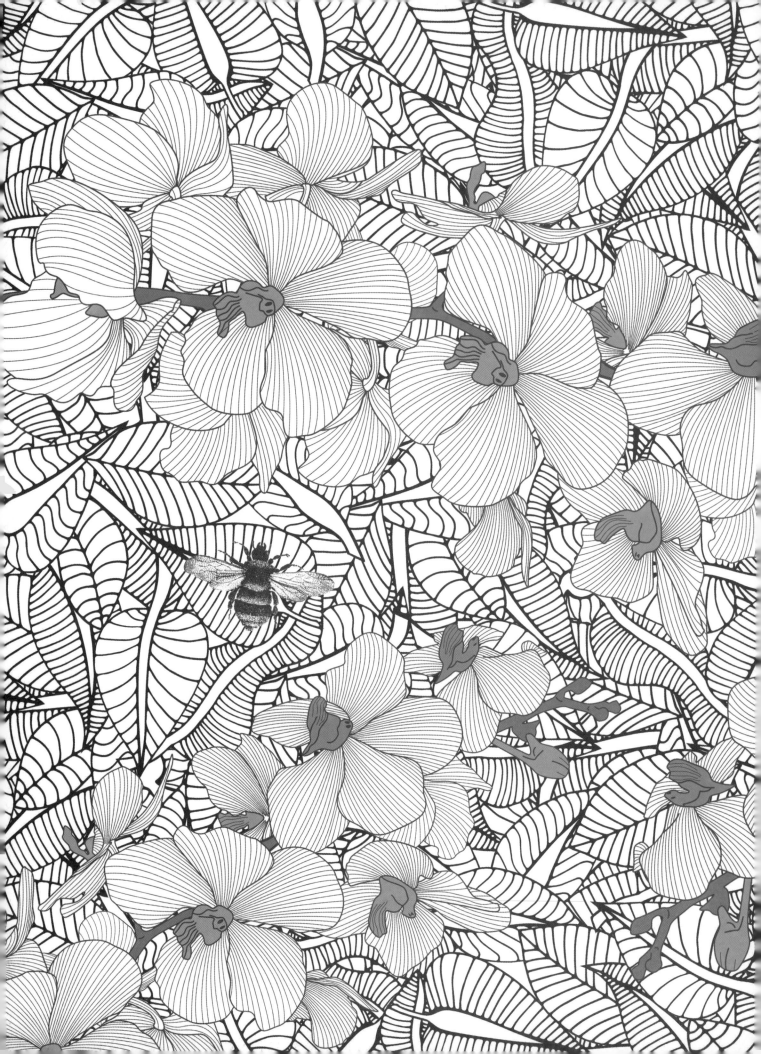

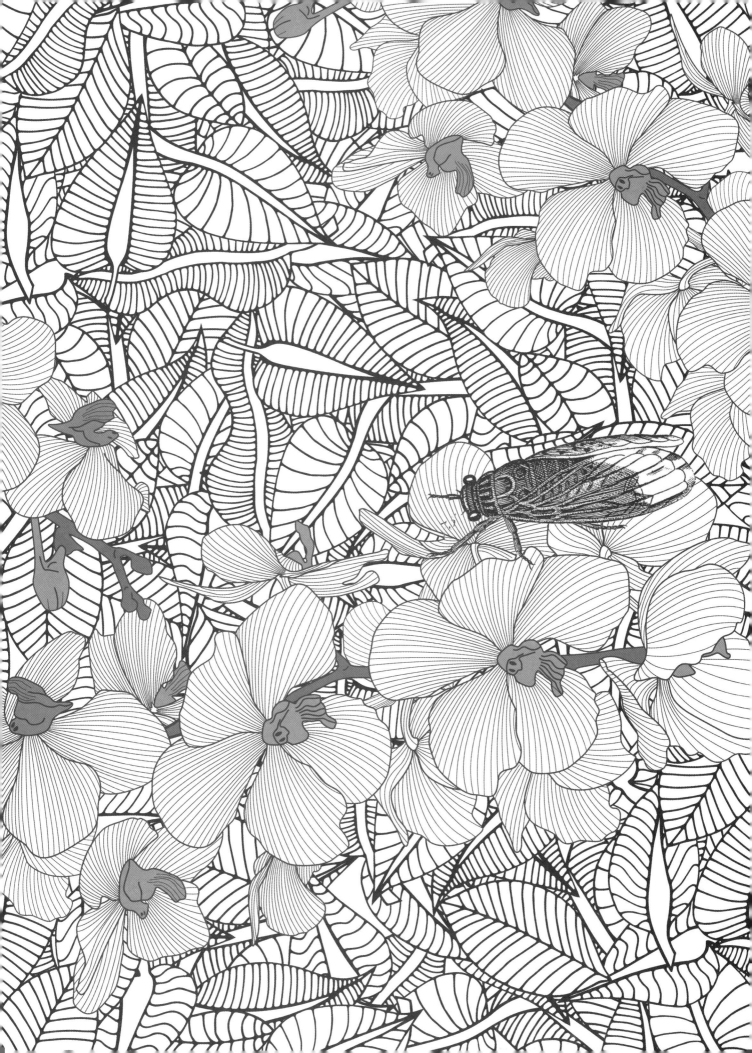

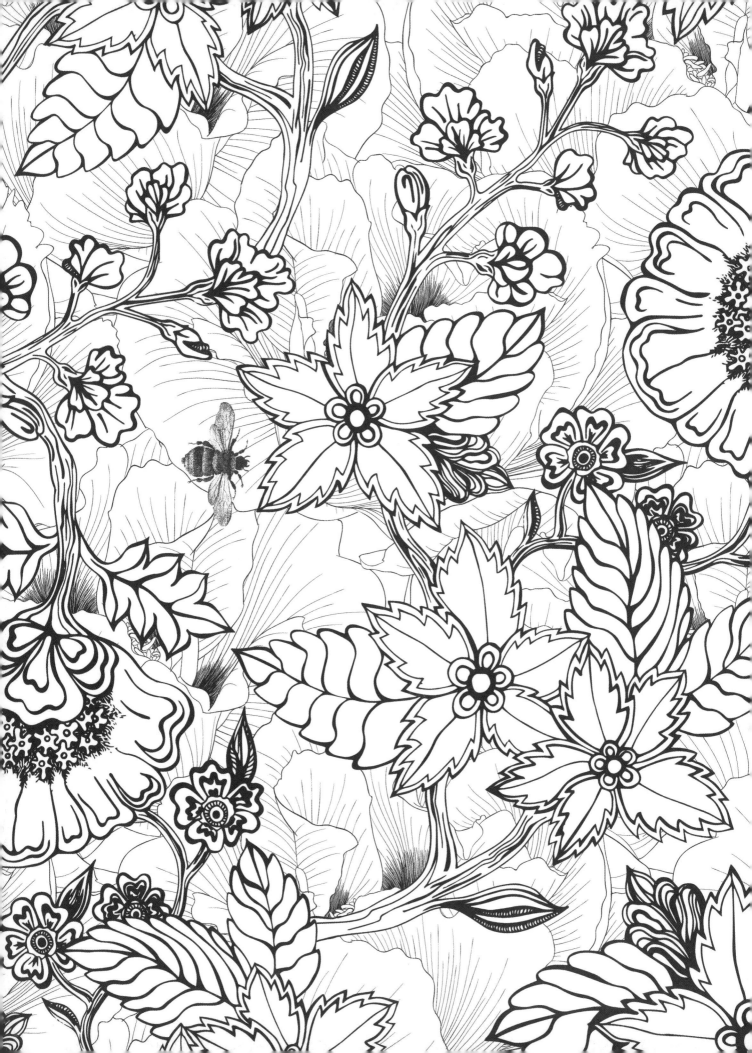

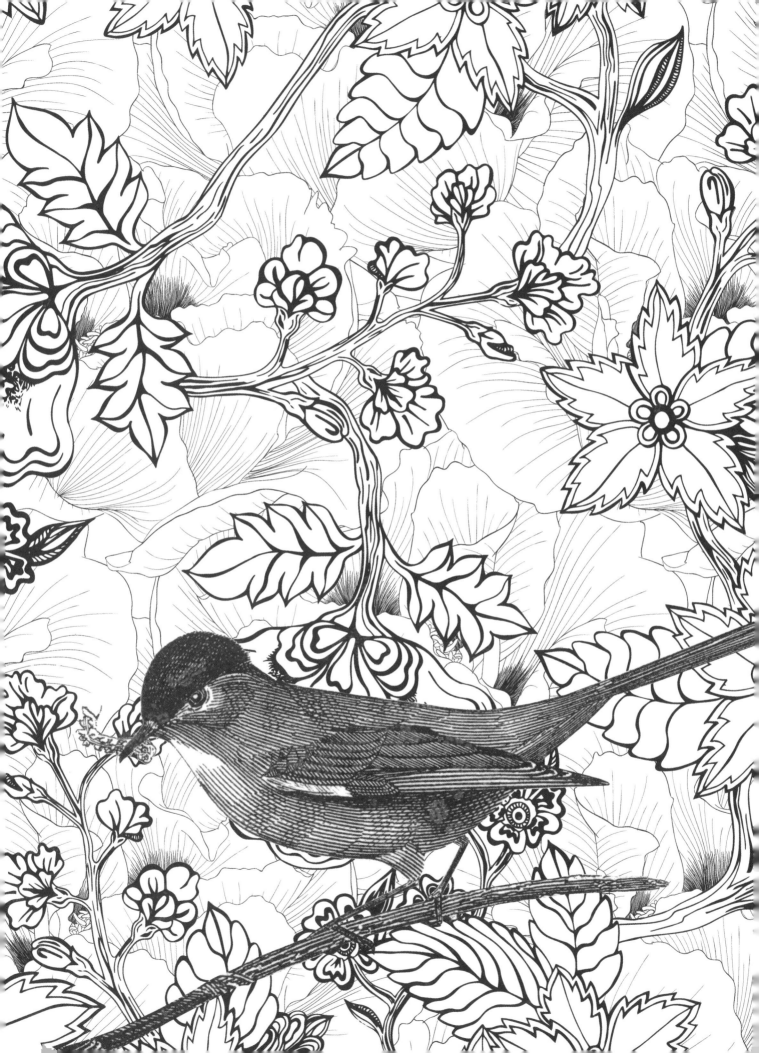

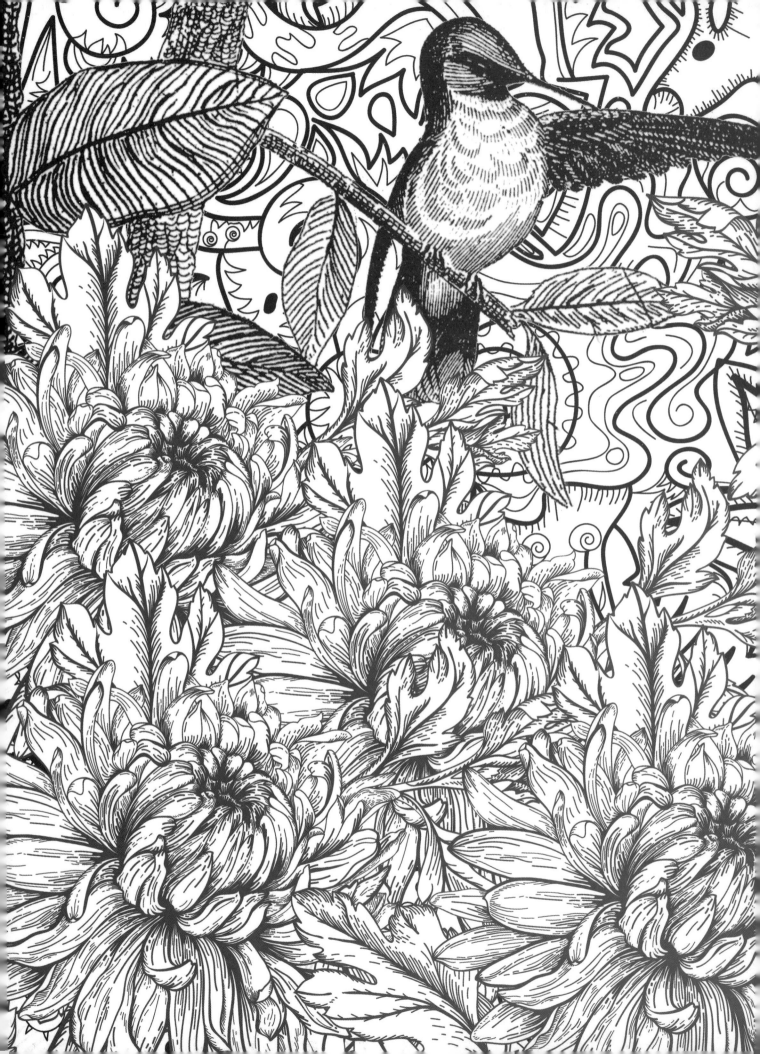

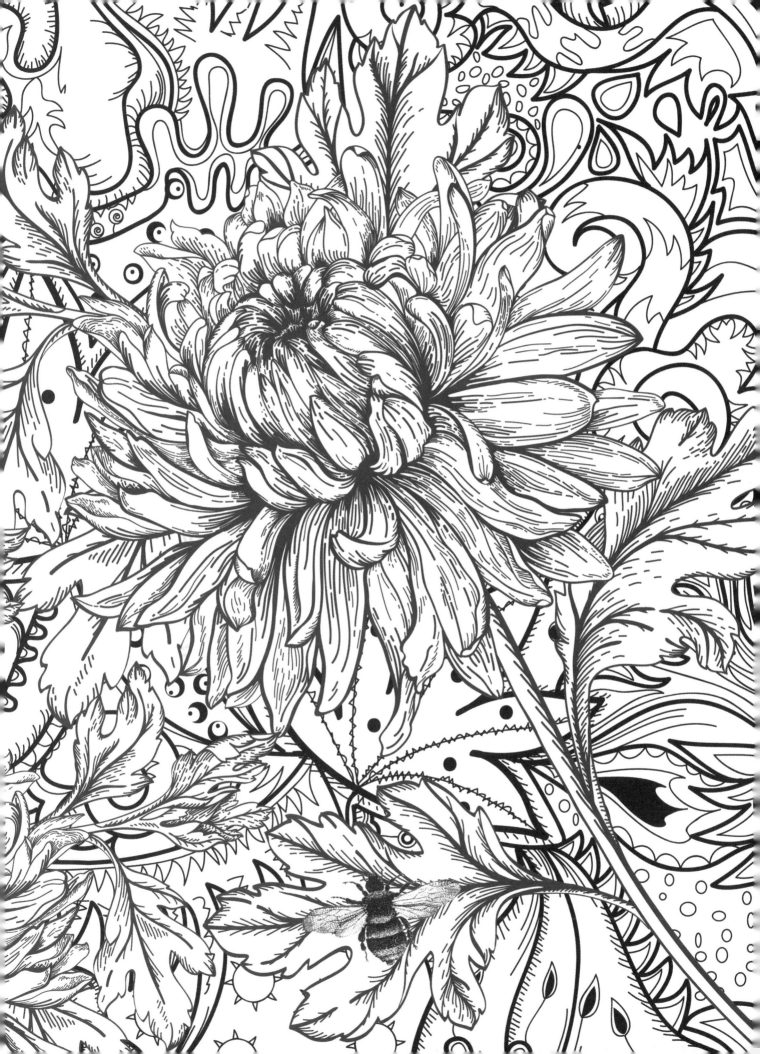

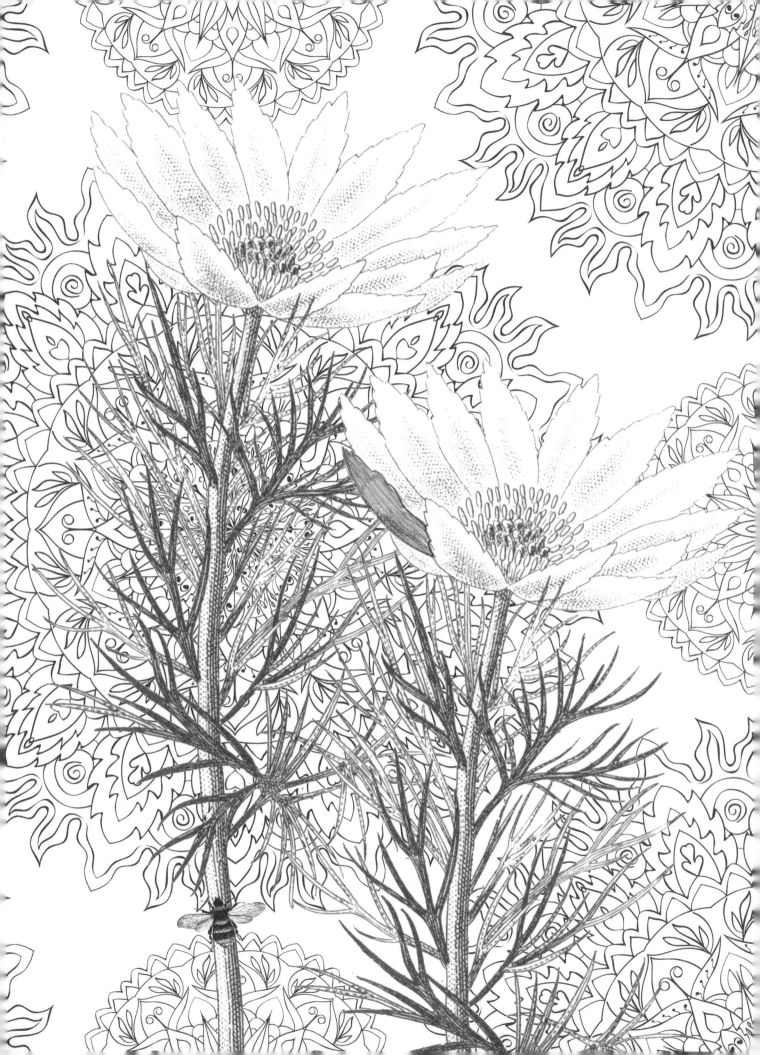

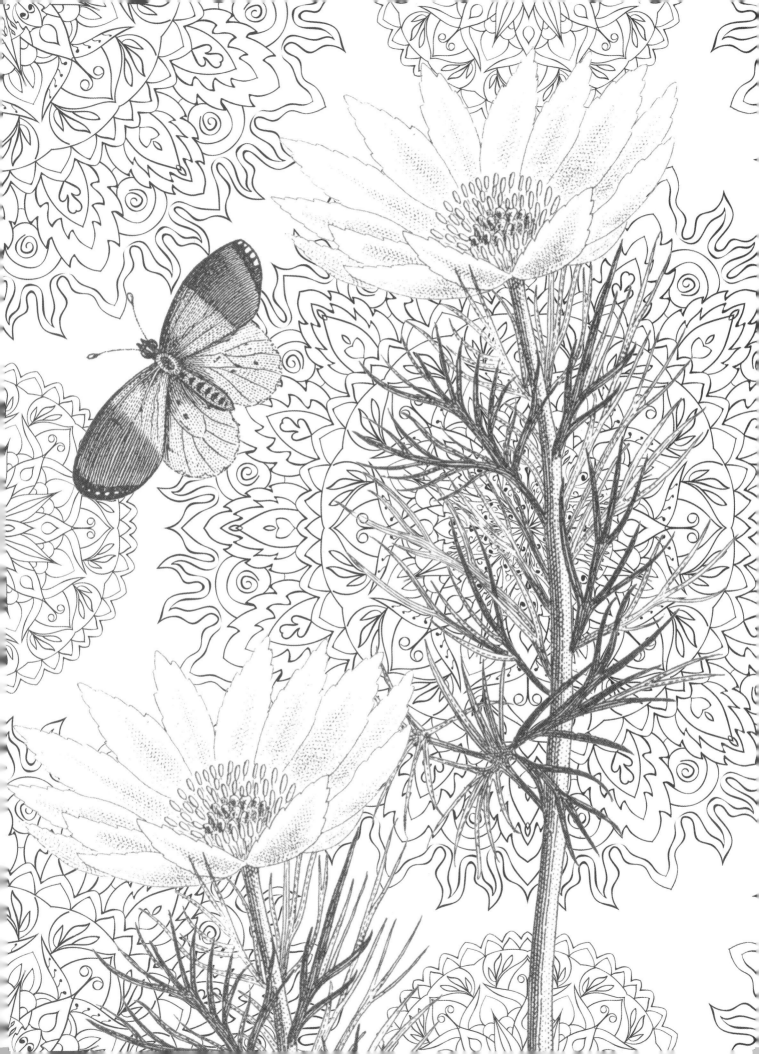

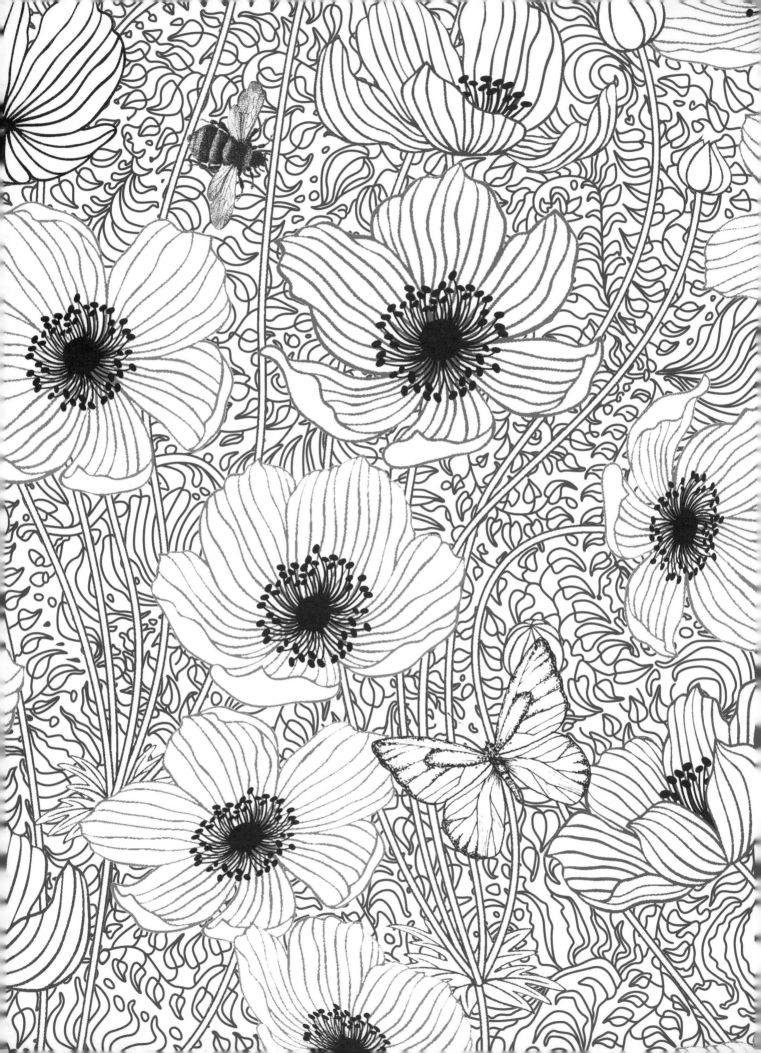

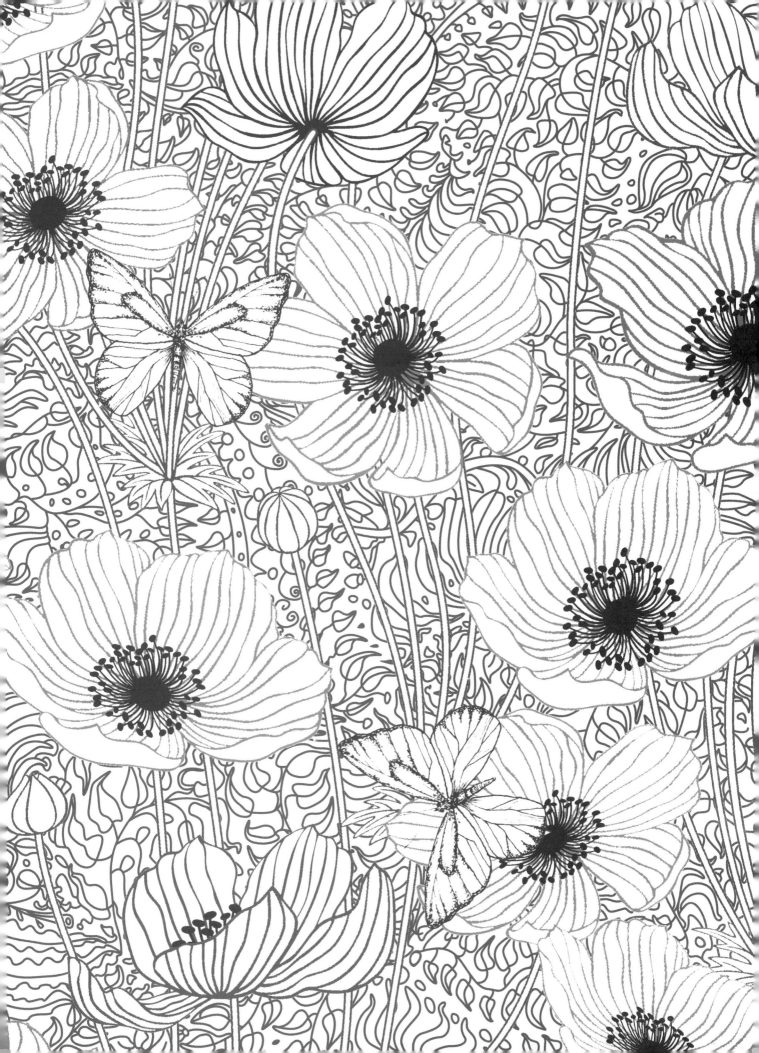

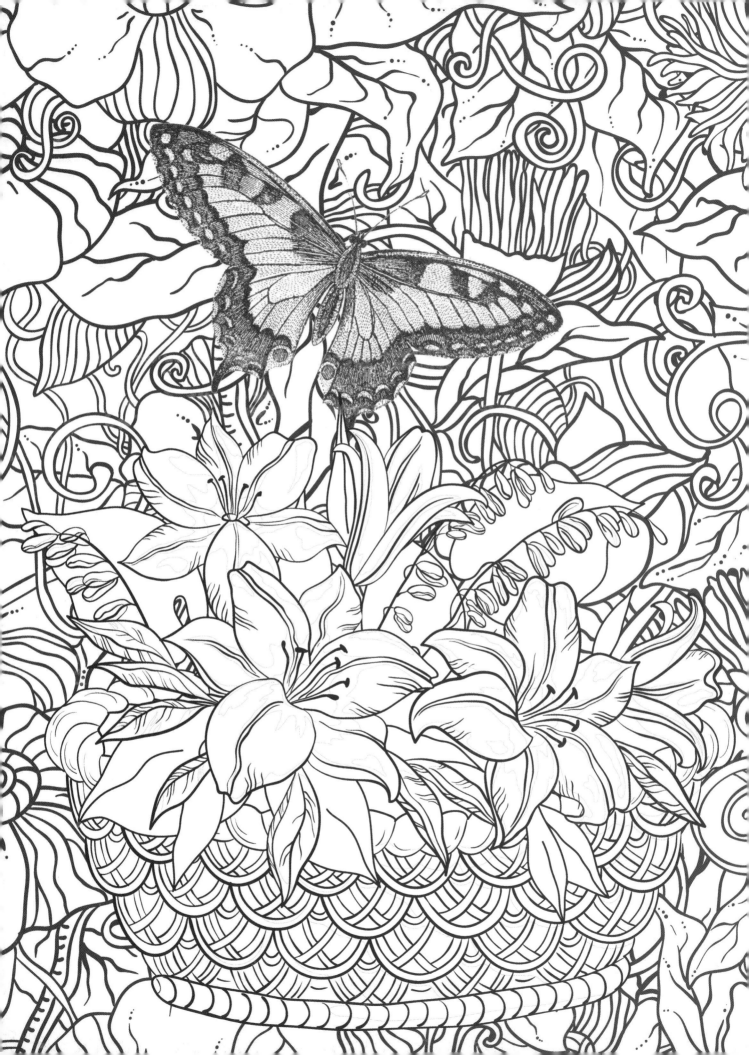

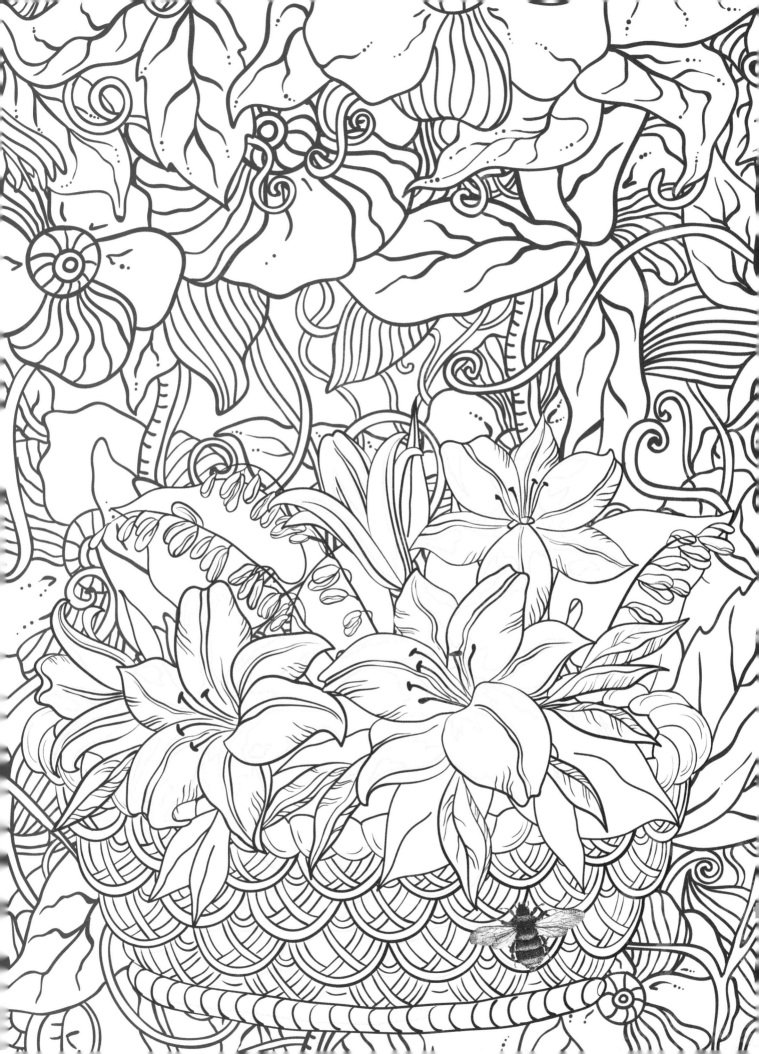

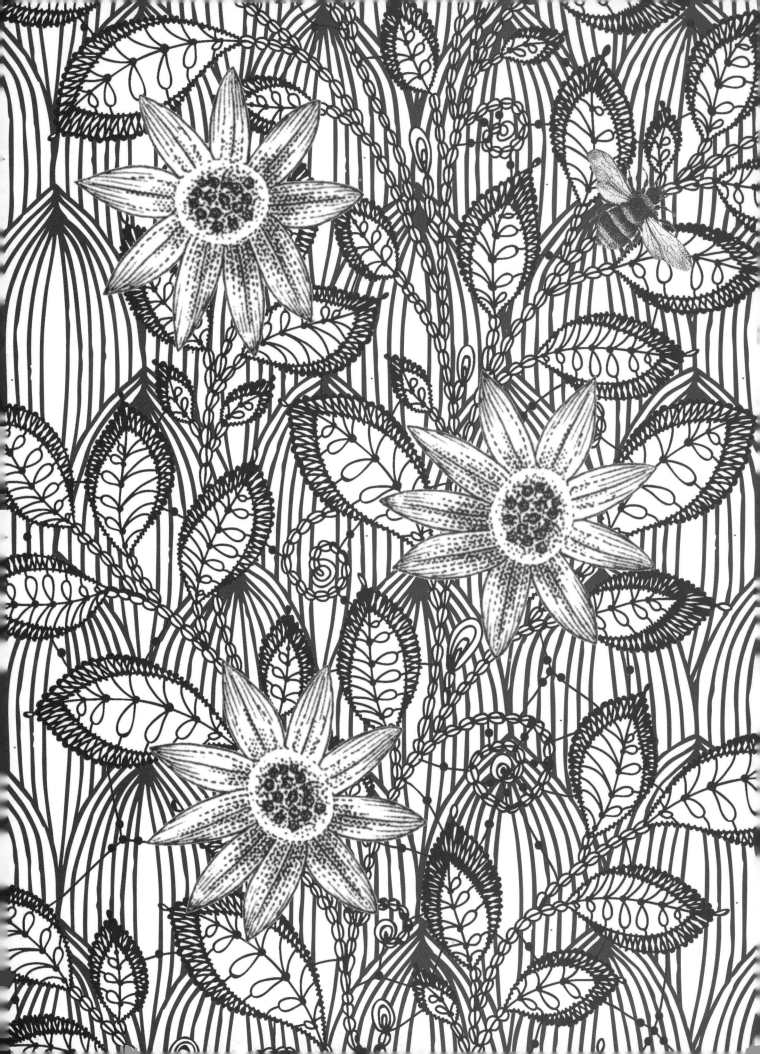

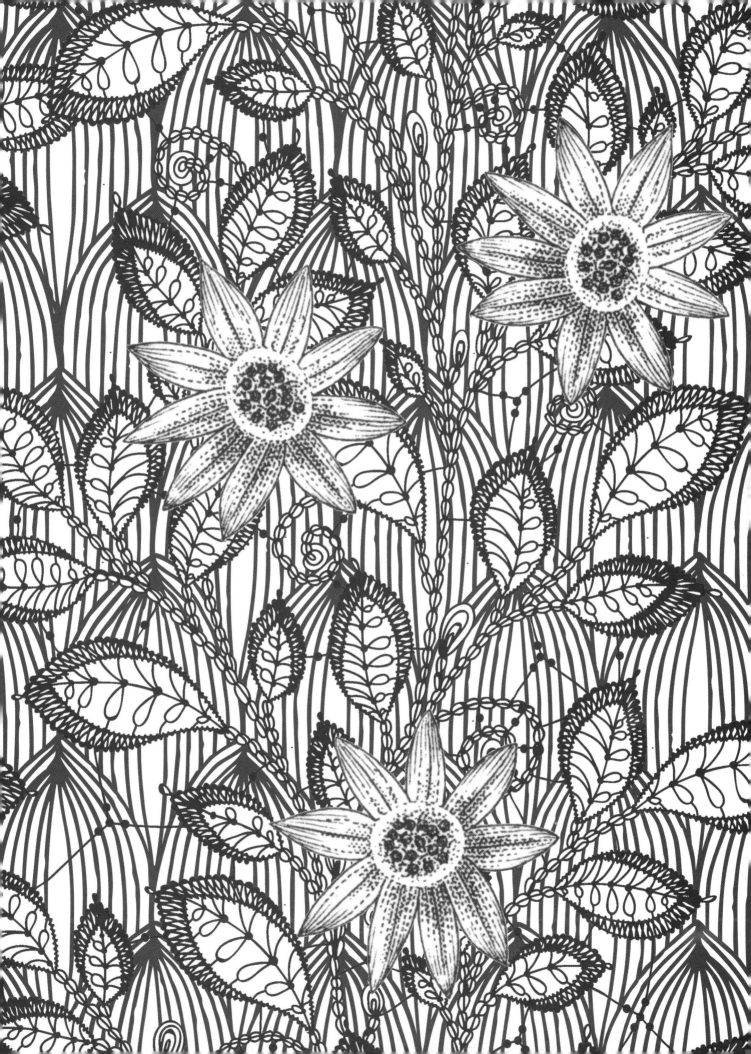

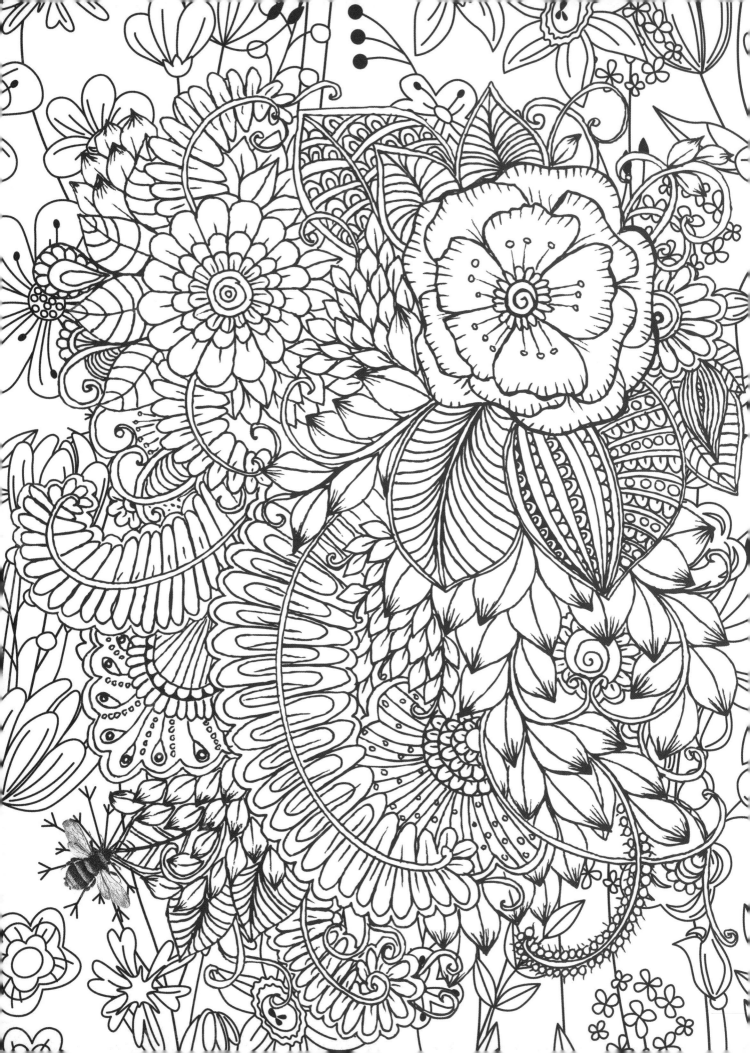

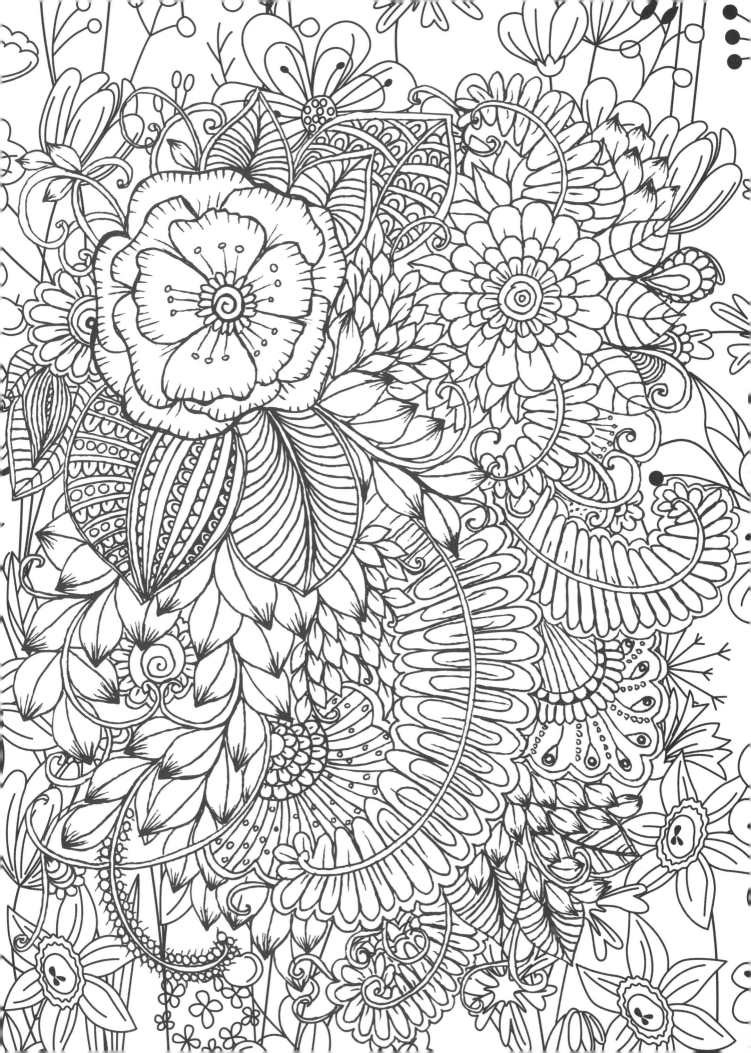

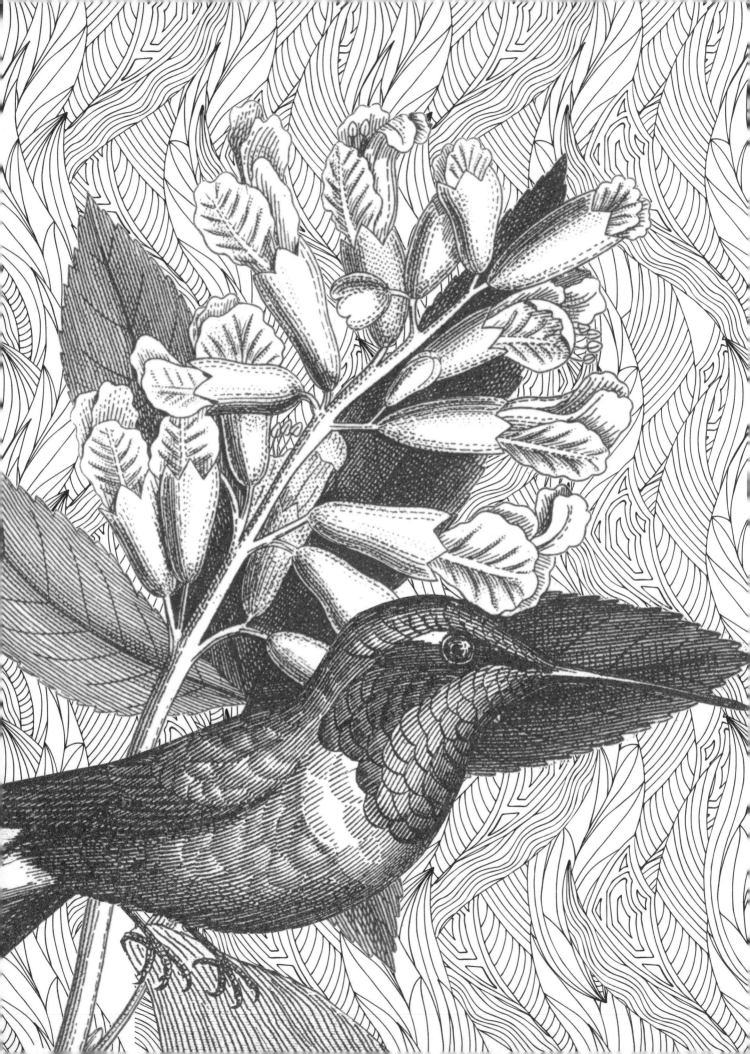

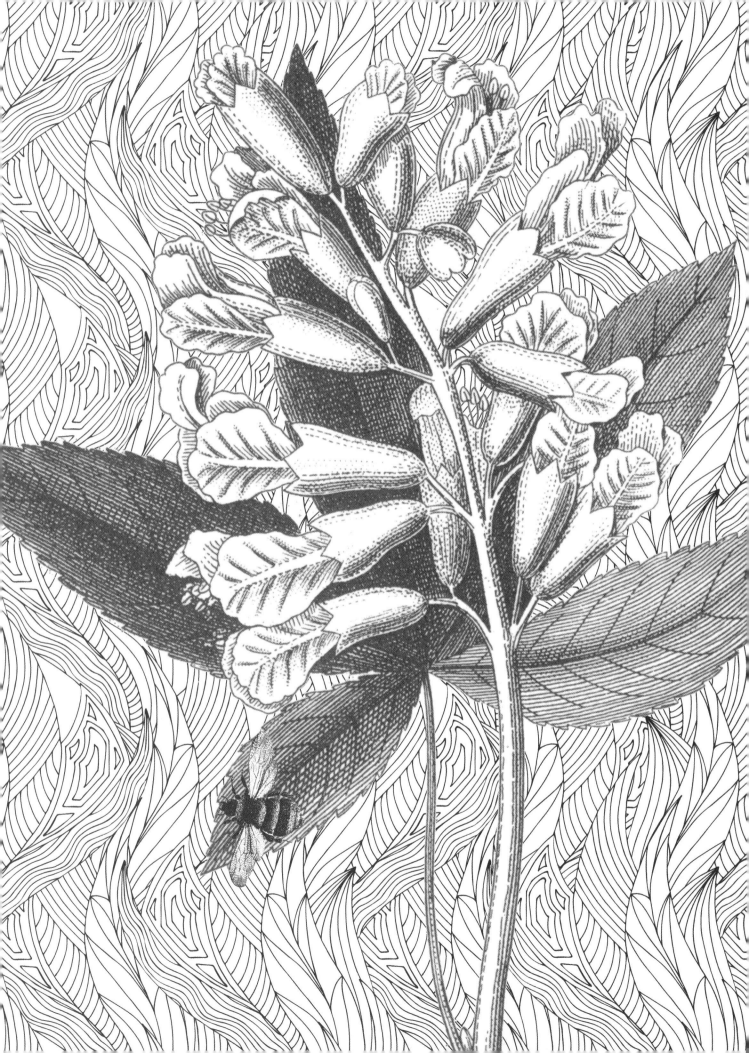

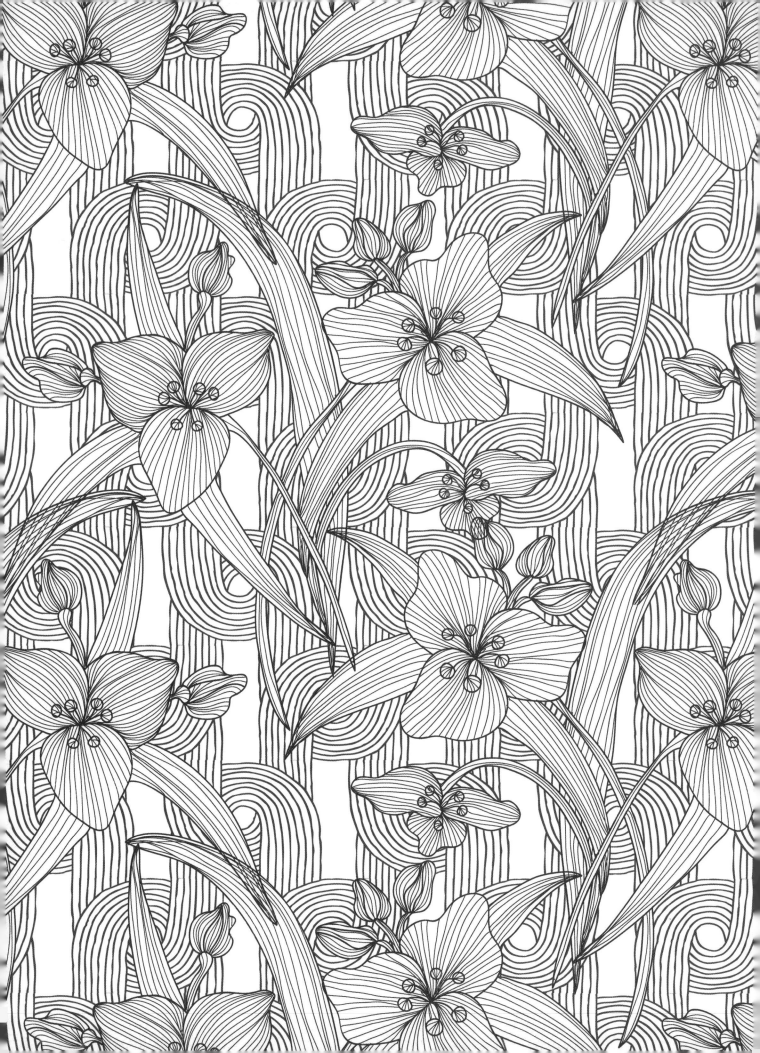

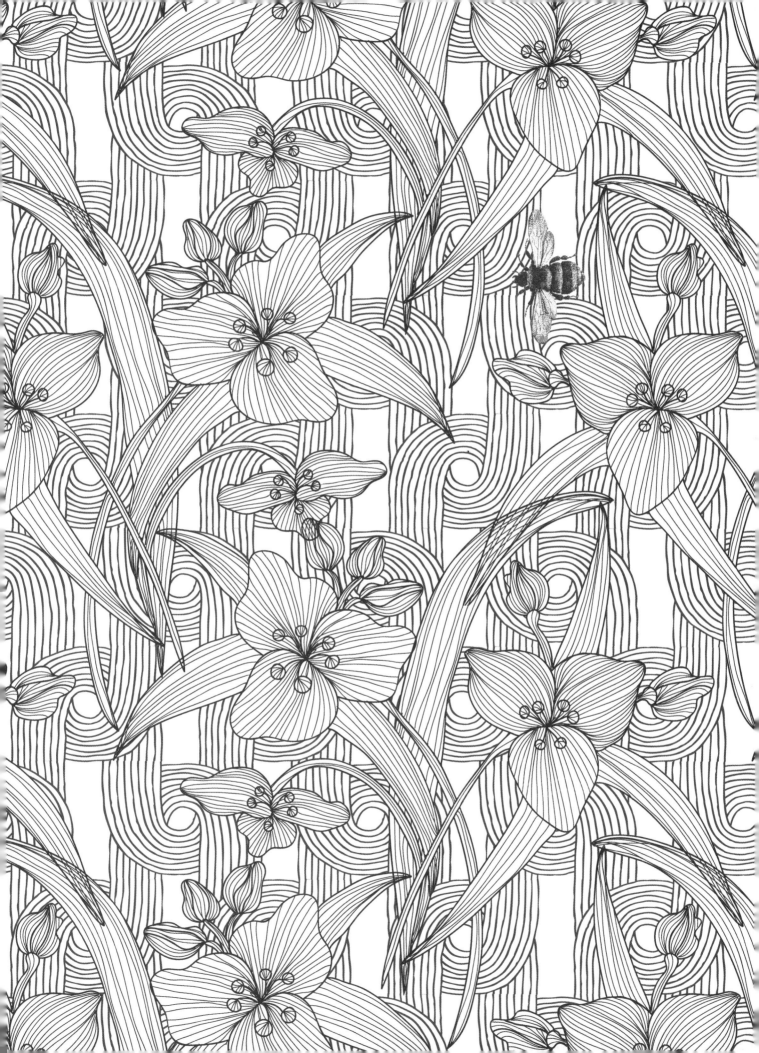

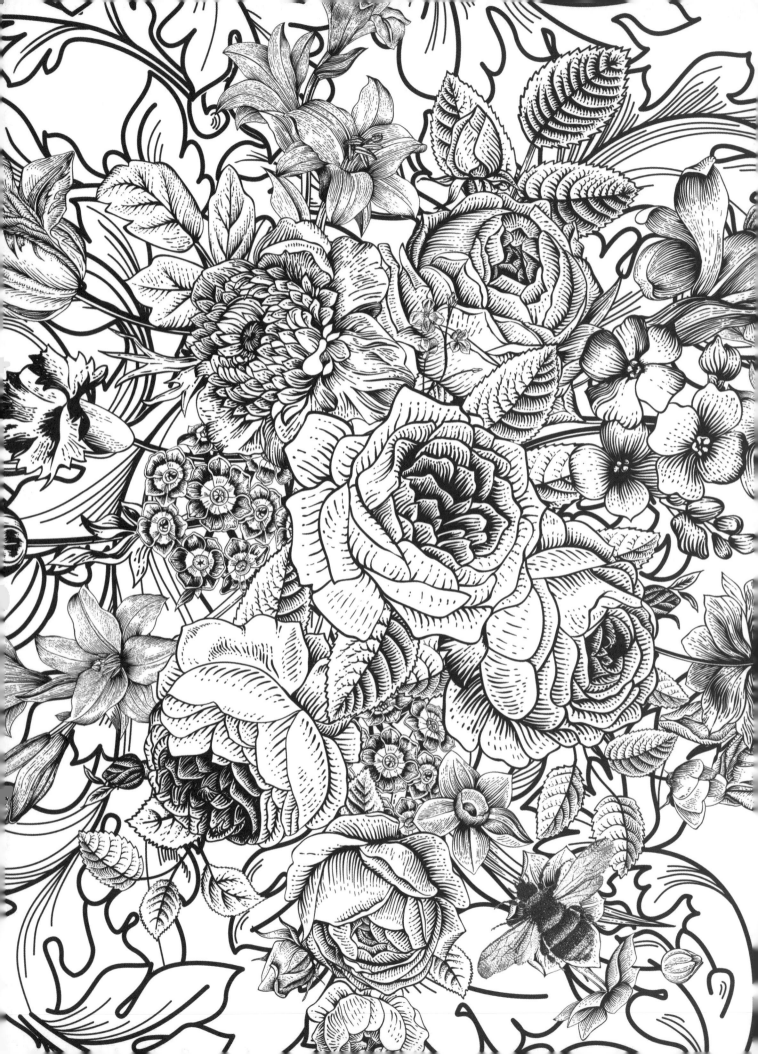

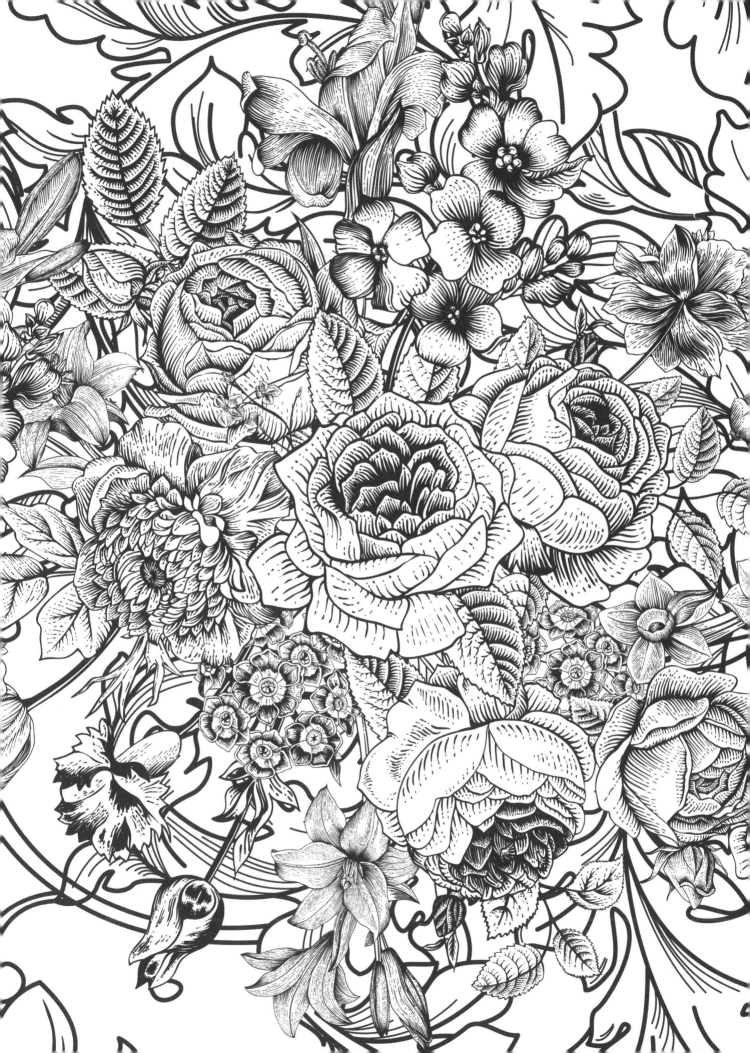

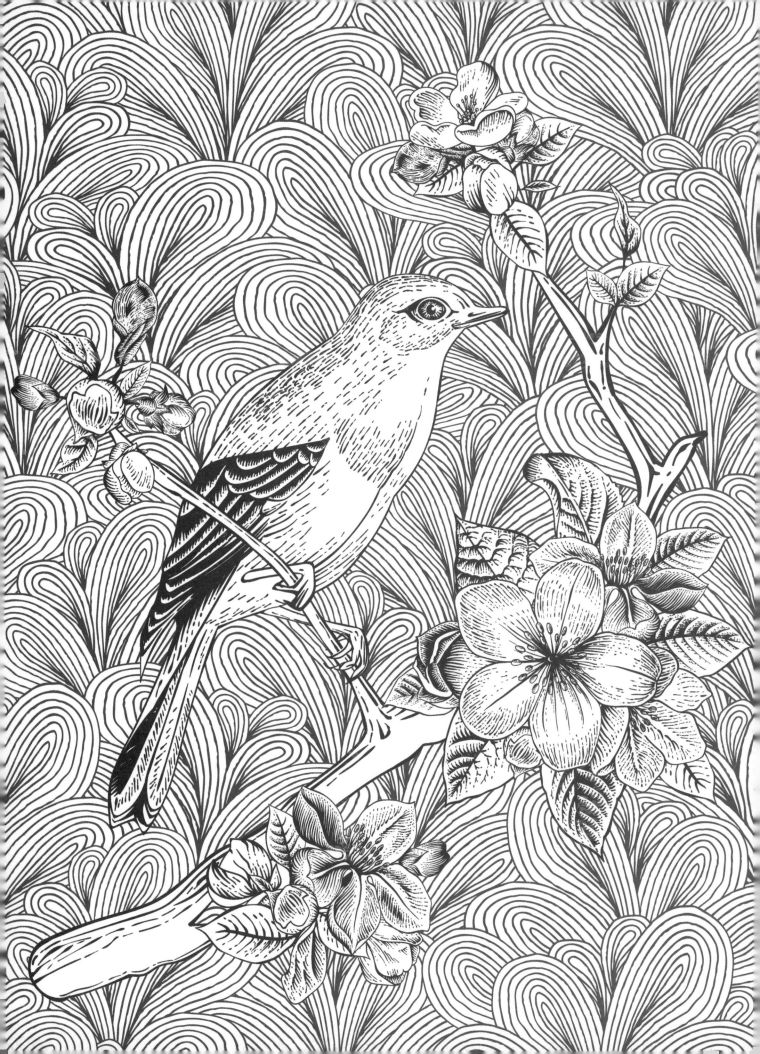

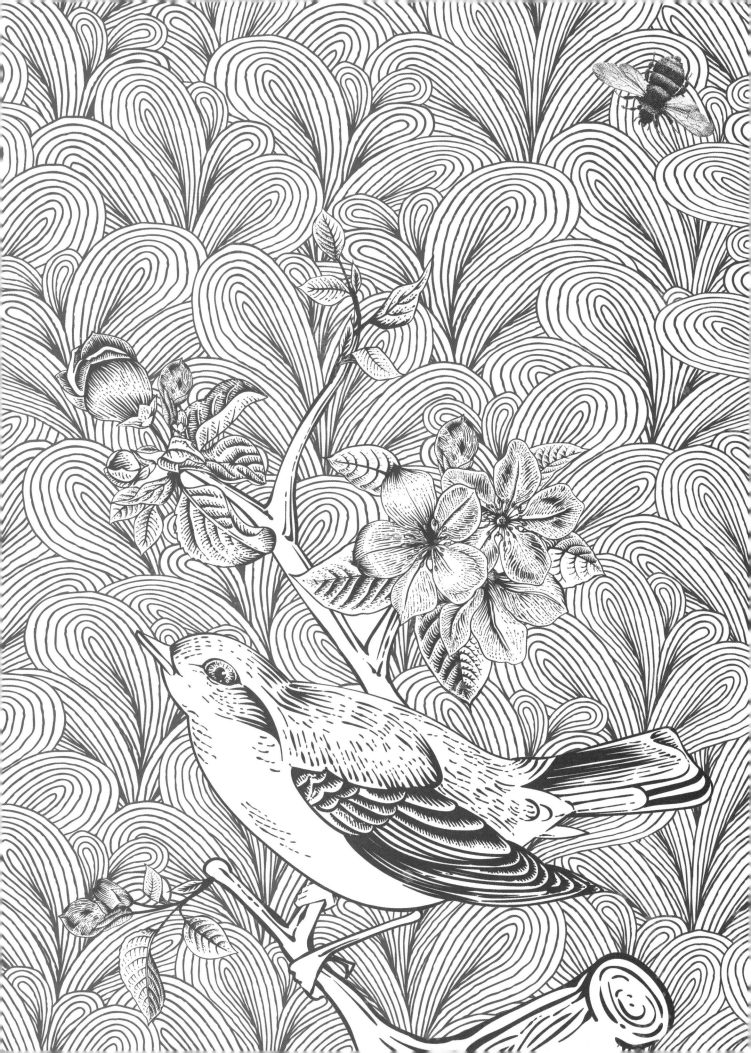

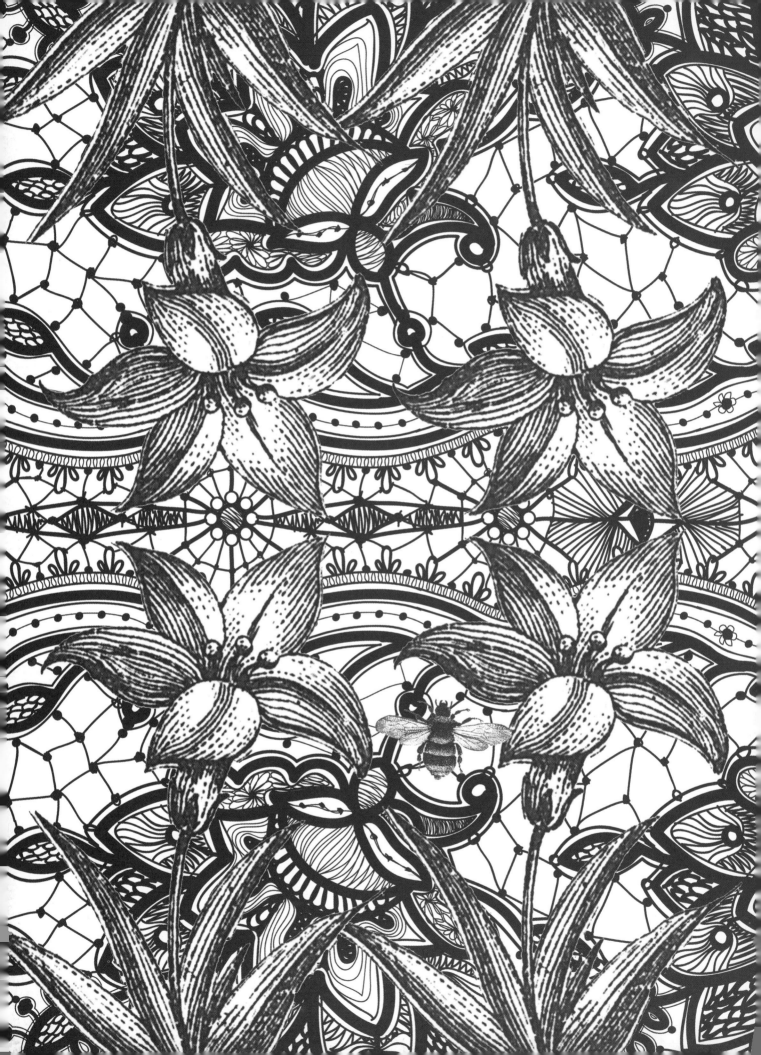

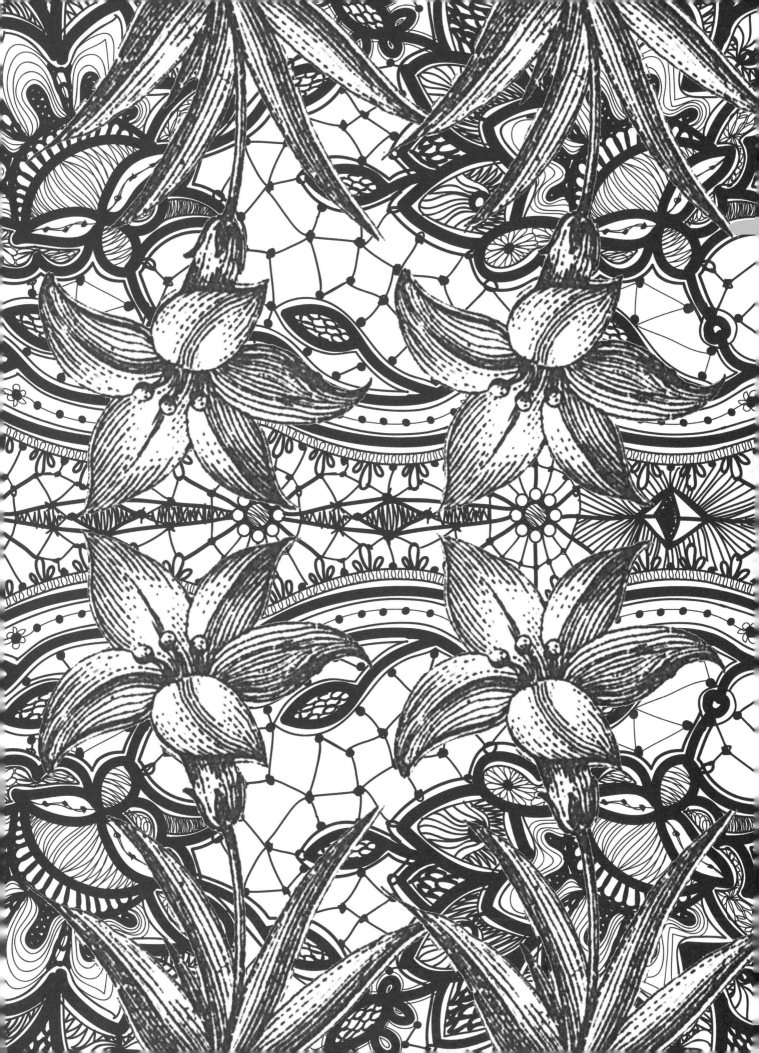

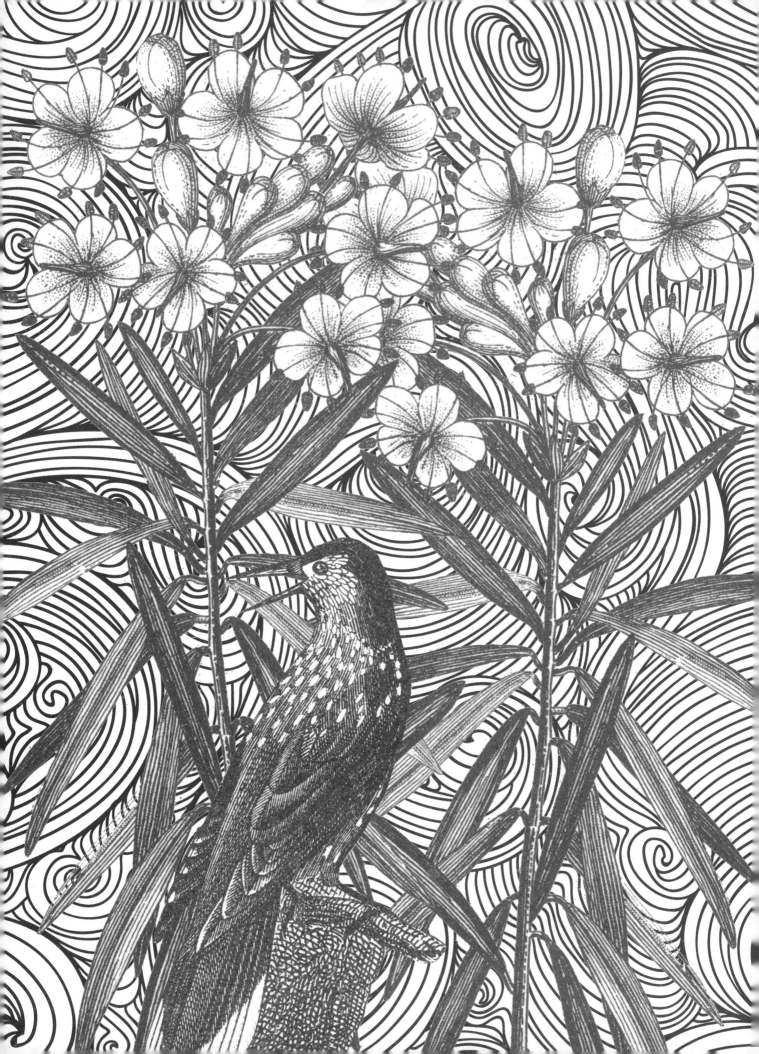

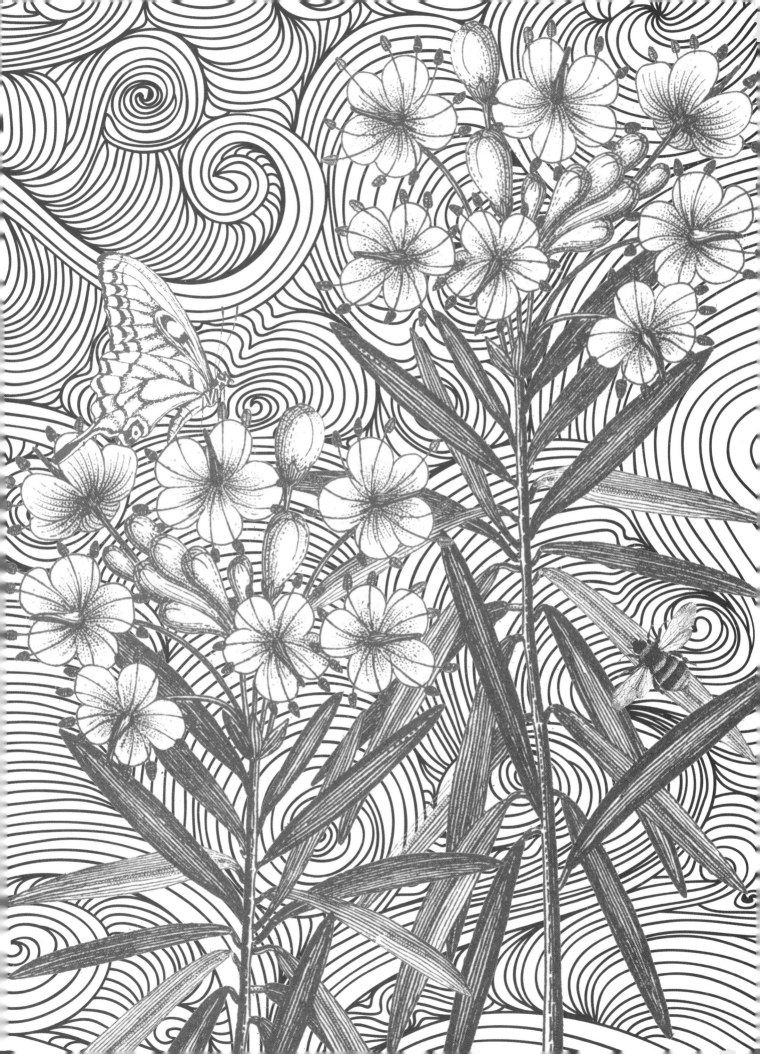

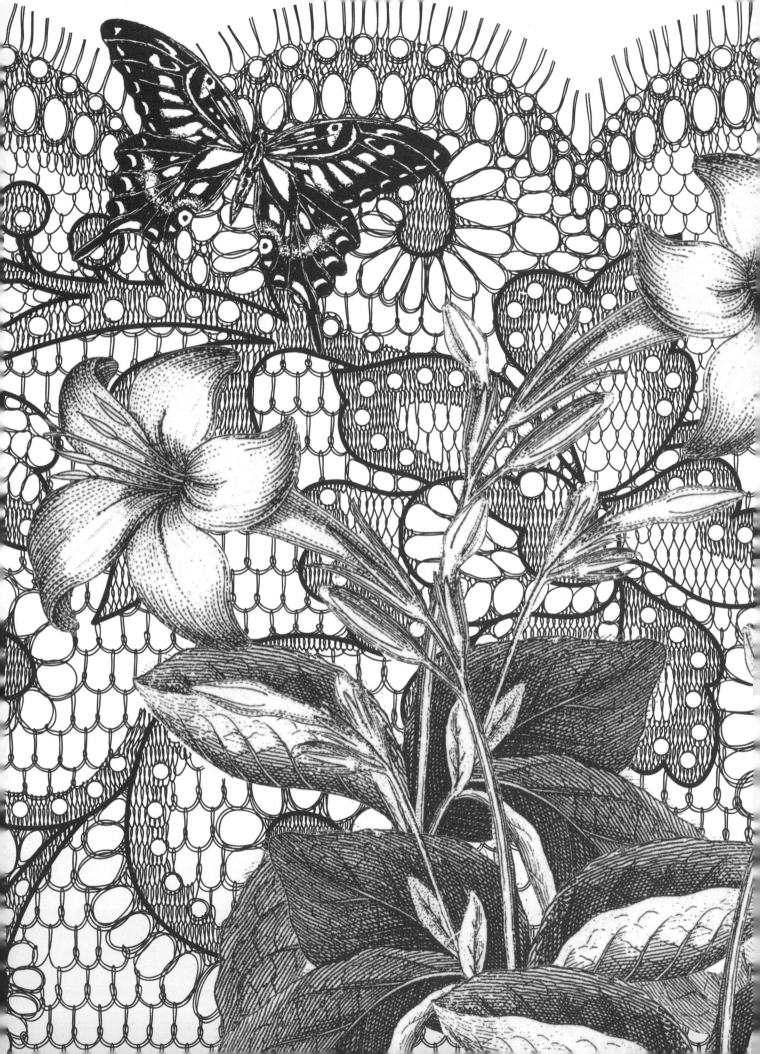

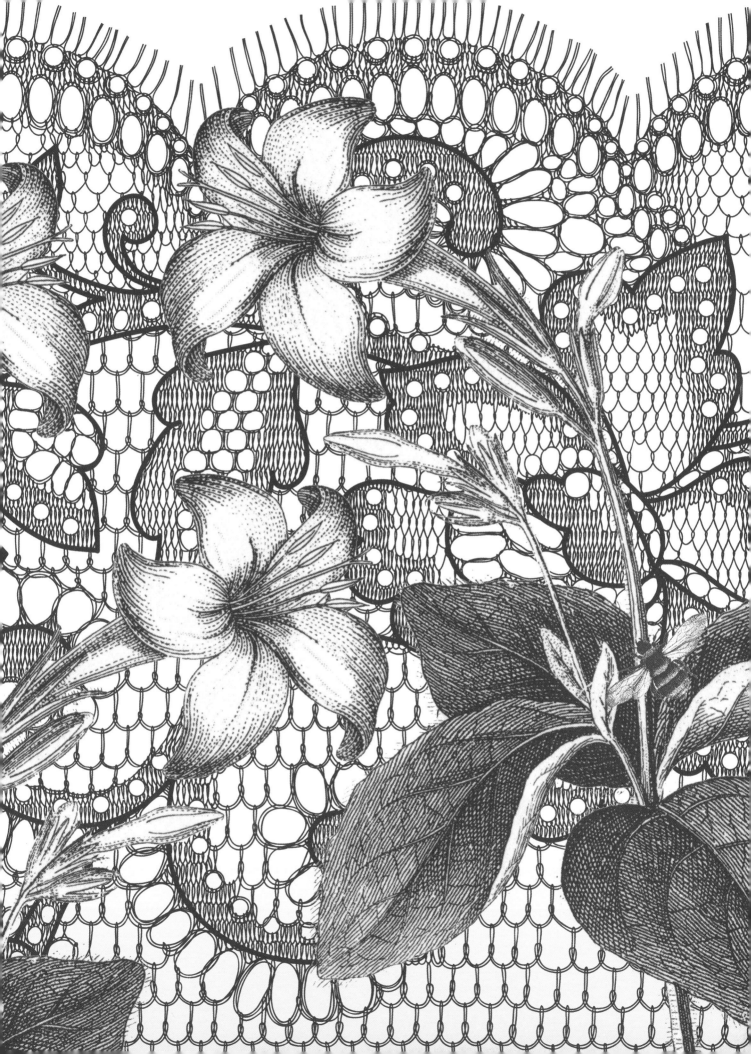

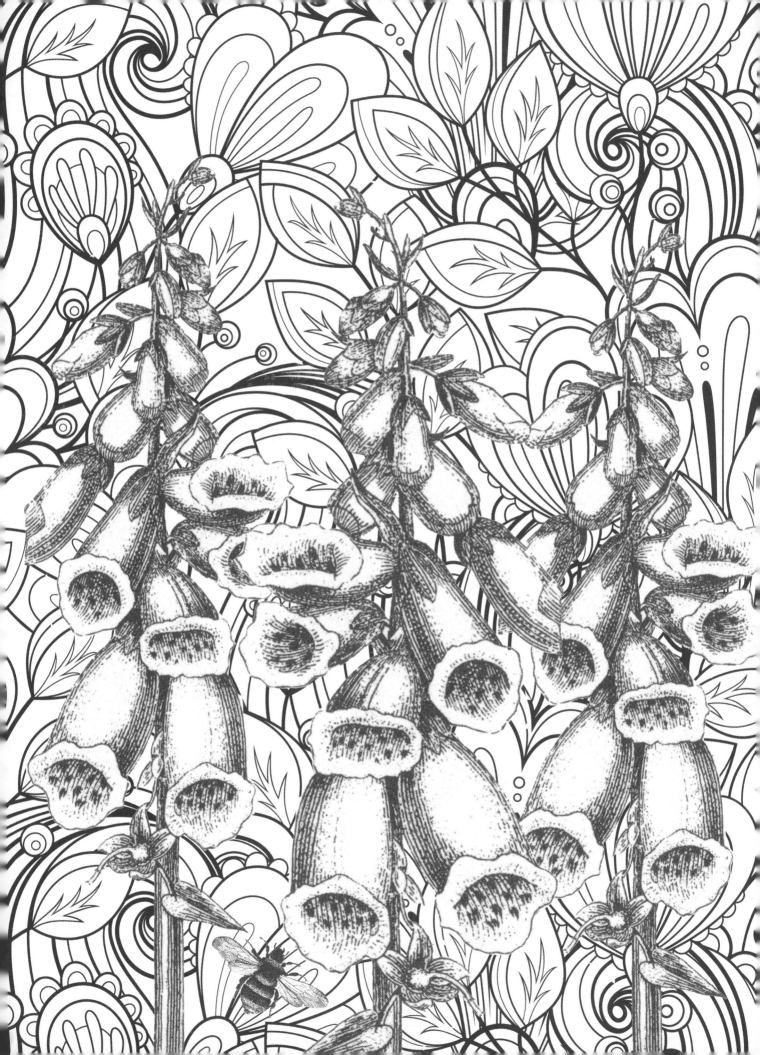

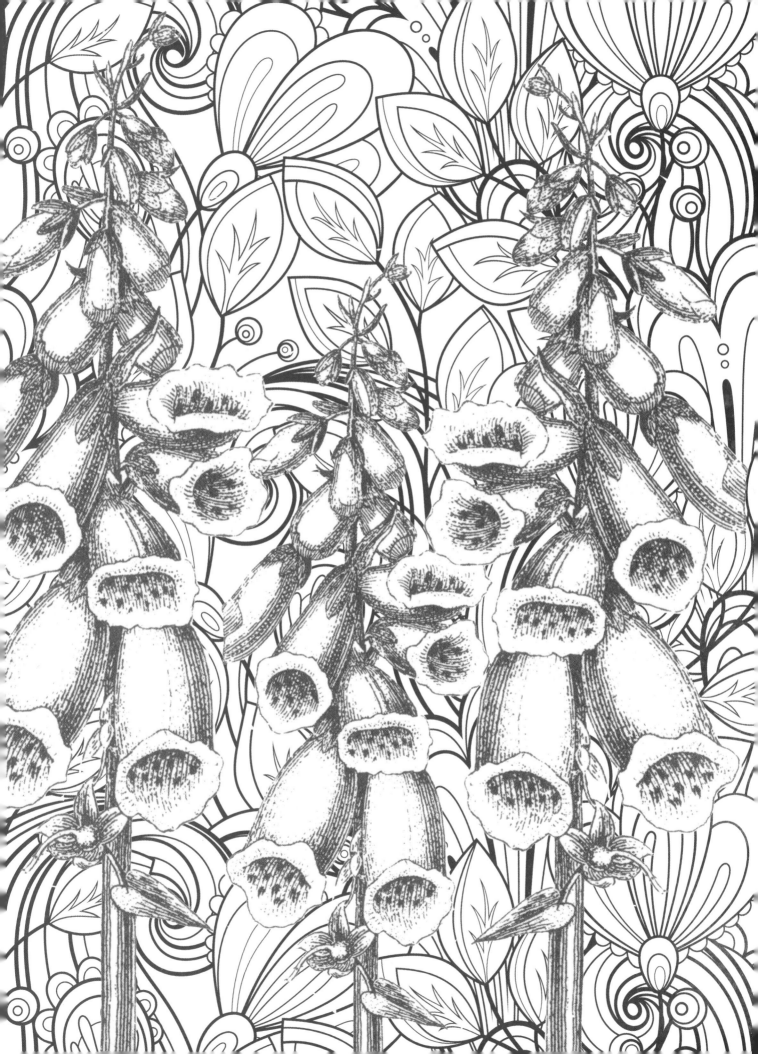

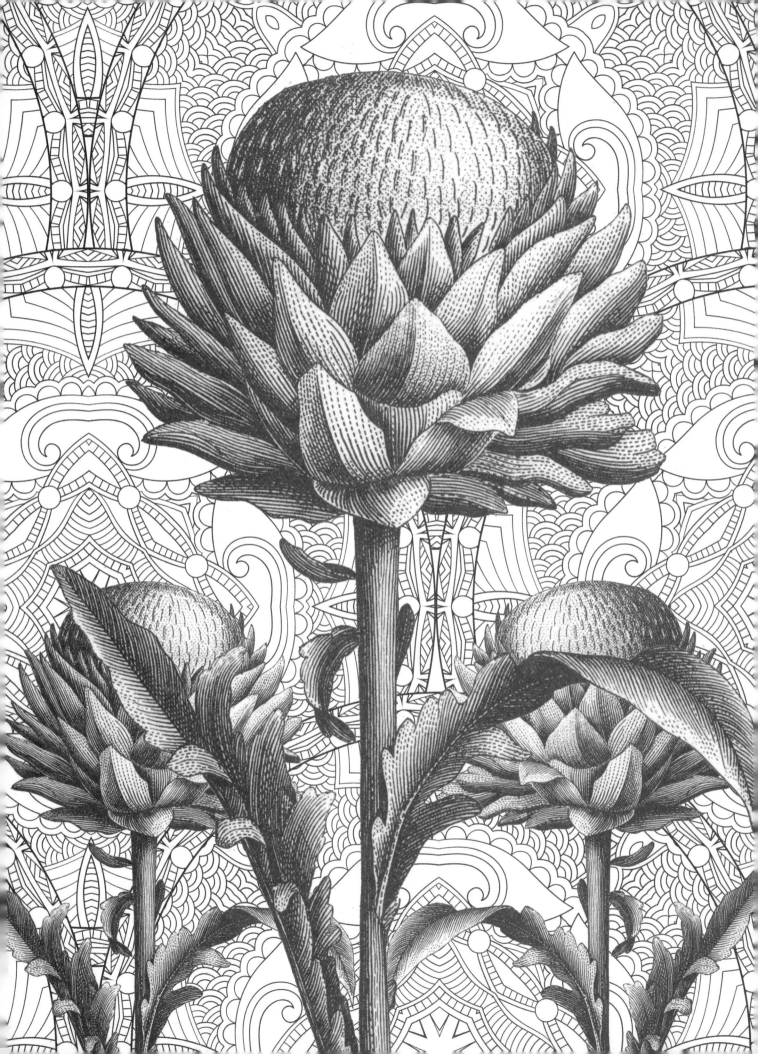

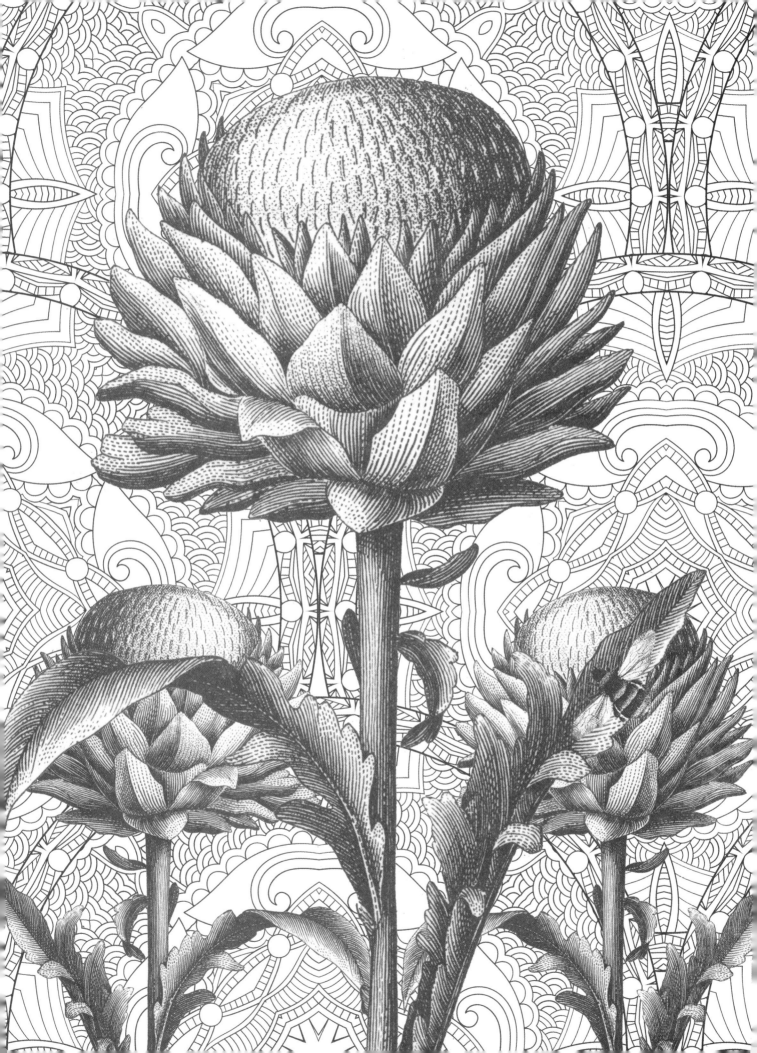

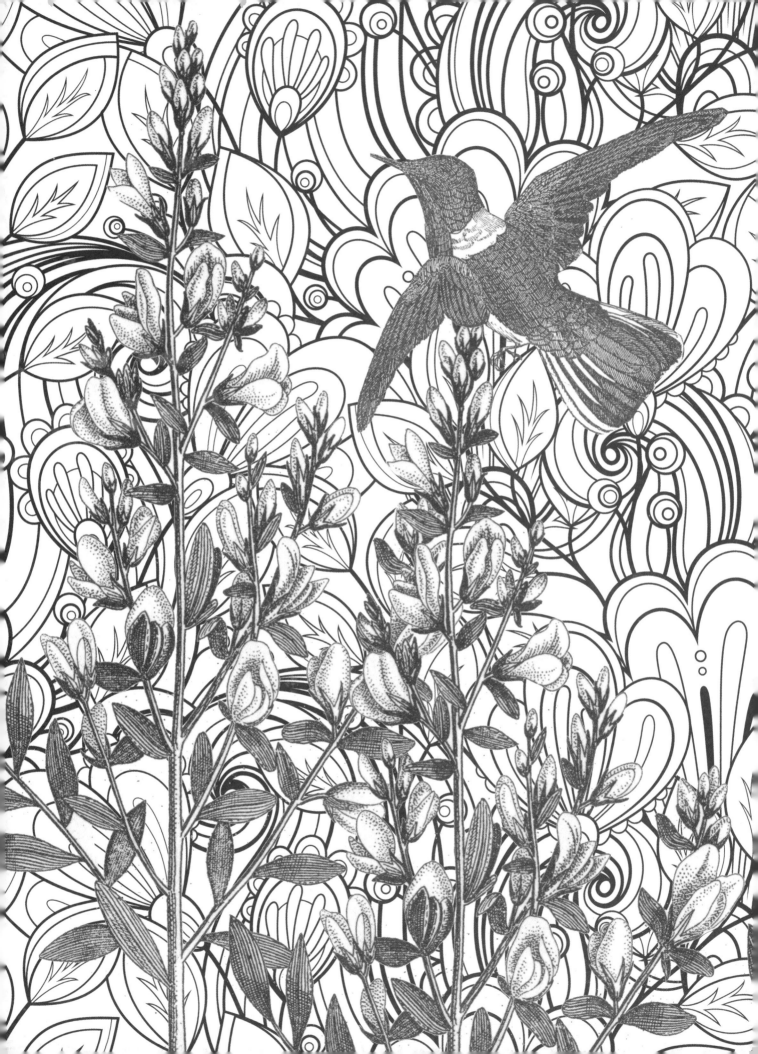

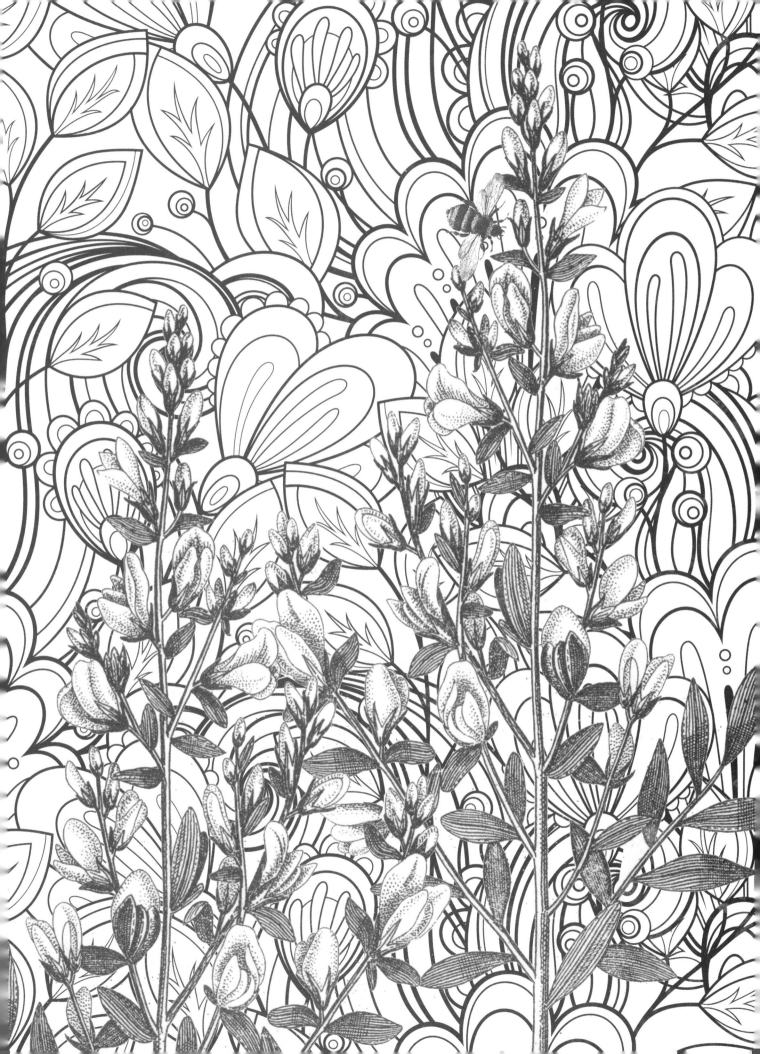

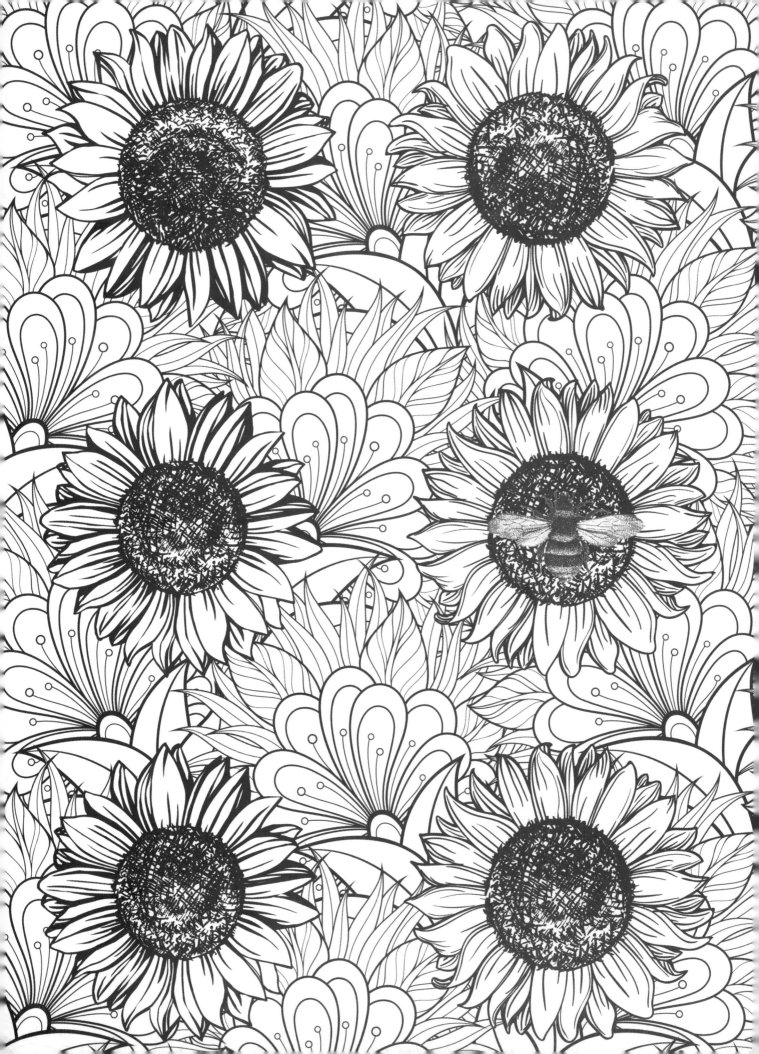

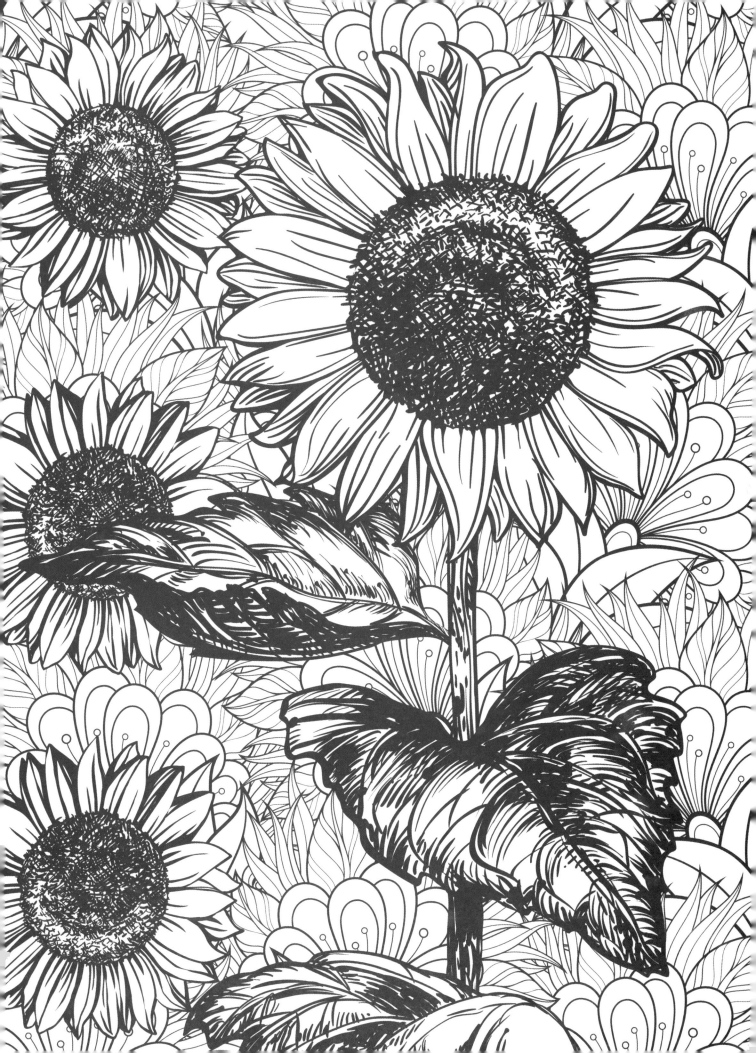

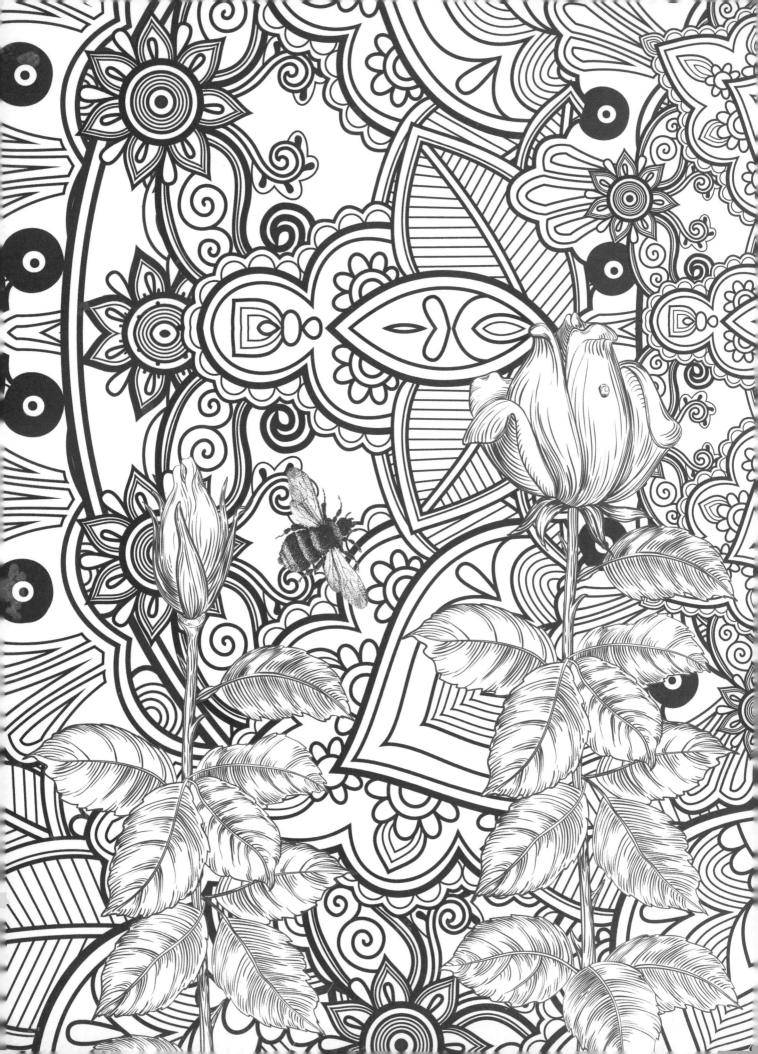

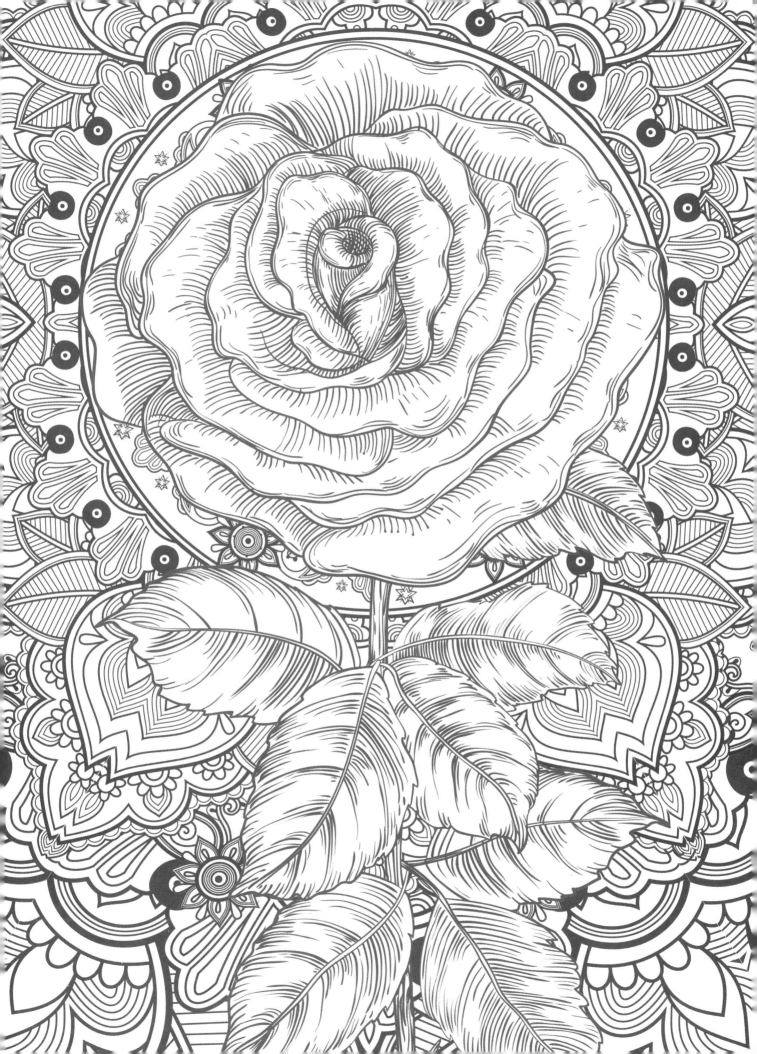

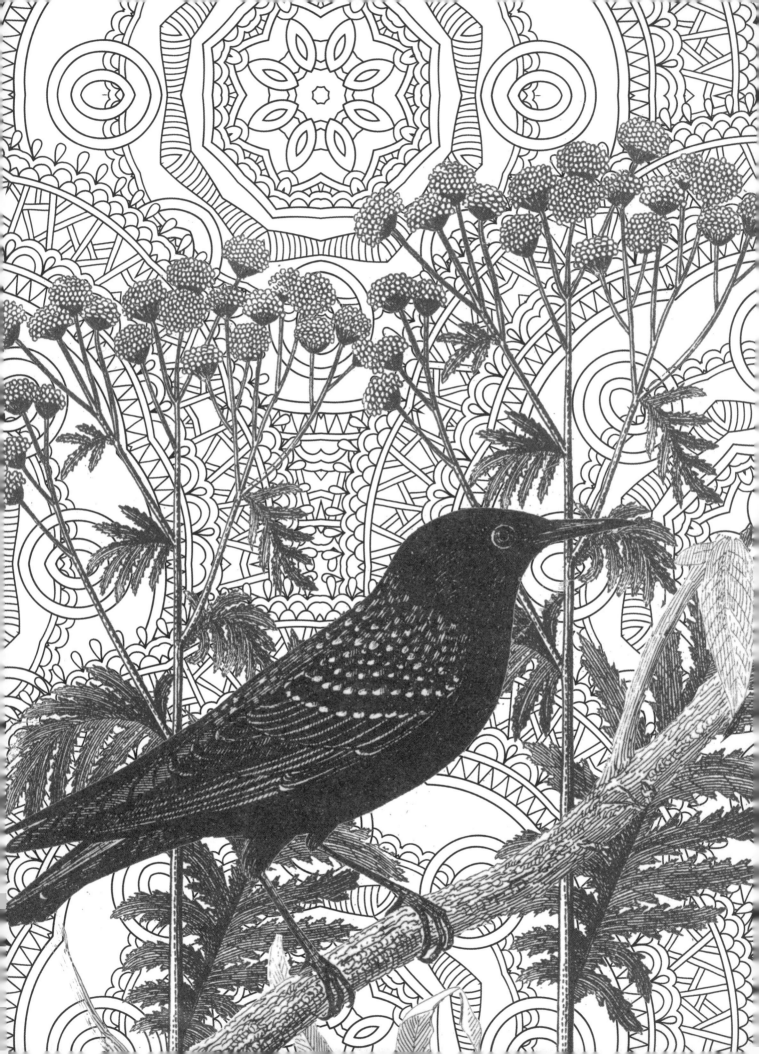

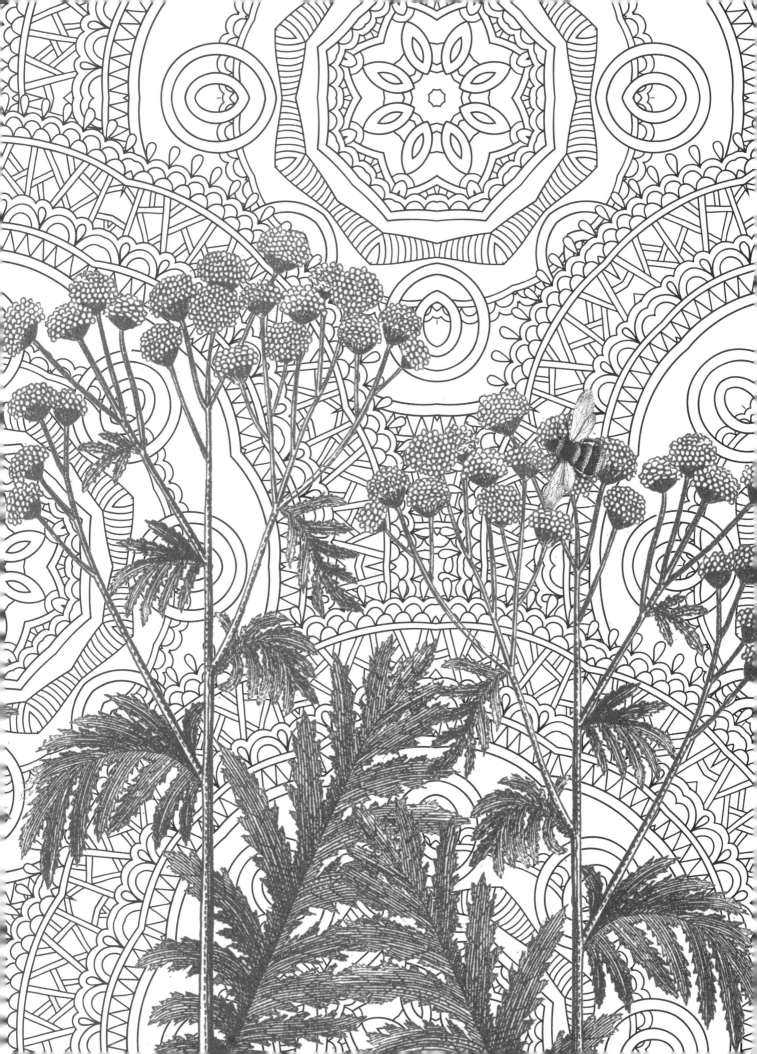